PAGE LAYOUT

PAGE LAYOUT

INSPIRATION • INNOVATION • INFORMATION

GENERAL EDITOR: ROGER WALTON

PAGE LAYOUT

First published in 2000 by:
HBI, an imprint of HarperCollins Publishers
10 East 53rd Street
New York, NY 10022-5299
United States of America

Distributed in the United States
and Canada by:
North Light Books, an imprint of F & W Publications, Inc.
1507 Dana Avenue
Cincinnati, OH 45207
1-800-289-0963

Distributed throughout the rest
of the world by:
HarperCollins International
10 East 53rd Street
New York, NY 10022-5299
Fax: (212) 207-7654

ISBN 0688-17989-4

First published in Germany by Nippan
Nippon Shuppan Hanbai Deutschland GmbH
Krefelder Str. 85
D-40549 Düsseldorf
Tel: (0211) 504 80 80/89
Fax: (0211) 504 93 26
E-Mail: nippan@t-online.de

ISBN 3-931884-63-5

Conceived, created, and designed by:
Duncan Baird Publishers
6th Floor, Castle House
75–76 Wells Street, London W1P 3RE

Designer: Sonya Merali
Editor: Simon Ryder
Project Co-ordinator: Tara Solesbury

10 9 8 7 6 5 4 3 2 1

Typeset in MetaPlus
Color reproduction by Scanhouse, Malaysia
Printed in Hong Kong

NOTE
All measurements listed in this book
are for width followed by height.

CONTENTS

FOREWORD

The job of the graphic designer is to communicate; after that there probably aren't any hard-and-fast rules. You can refine this a little by asking what it is that needs to be communicated and to whom but essentially the remit of the designer in the pursuit of effective communication is as wide and deep as the designer's imagination and that of the client.

The foundation of any design job includes the brief (information, materials, and thoughts provided by the client), the schedule (how much time you have overall and how much of your client's time within that), and the budget. These are the parameters and ingredients within and upon which you must bring your imagination to bear. As the work shown in this book demonstrates again and again, of these three elements what ultimately makes a design successful is the designer's imagination—not the source material, the amount of money available, or the production process. Be it an item of stationery, a website, or a calendar to promote manufacturers of machinery used in the production of paperboard, what gives the designs in this book their

edge is the way in which individual designers have analyzed the requirements and constraints of the job and responded with exceptional imagination and flair.

The title *Page Layout* has been interpreted in the widest sense possible. It is intended to be an expression more of the design process than of the format in which the final design is realized. Increasingly, among the questions under consideration by the designer is what form the communication should take—a book, leaflet, brochure, press announcement, website, series of billboard posters, television advertisement—or a sidewalk performance? I would say there are circumstances in which each of the above might be appropriate, along with many other possibilities.

Page Layout comprises a wide range of designs drawn from all over the world that show imagination working at the highest level. This work can be seen as a stepping-off point from which your imagination can roam freely and creatively—an inspiration for future designs.

RW

DESIGN FOR DESIGN

This opening section shows designers promoting themselves, the company they work for, or another company within the design sphere. The work ranges from the intensely personal—a book exploring the impact of new media on graphic design, for example—to more obviously commercial projects, such as posters to advertise typefaces, sets of stationery, and furniture-design brochures.

SECTION ONE

Designers
Red Design

Design Company
Red Design

Country of Origin
UK

Description of Artwork
8-page promotional
brochure for the product
design company Bo Bo.

Page Dimensions
210 x 135 mm
8¹/₄ x 5¹/₄ in

Format
Brochure

The different color of
the cover close to the
spine, combined with
the red line of the elastic
band, is reminiscent
of traditional leather
binding techniques. This
suggests a link between
the values involved in the
making of handmade
items and the company's
own philosophy.

Bo Bo Brochure

This stylish publication for a furniture design company comes attached to a
piece of translucent polyurethane, a reference to the types of material used in
the company's products. Inside, strong colors are used to set off the muted,
almost monochrome, tones of the photographs, while on some lefthand pages
a prismatic abstract background is suggestive of the way light passes through
a translucent material. Shots of personnel, conceptual drawings, and images
of furniture under construction are brought together under different headings
to give a very full picture of the company philosophy and practice.

No.2 | INNOVATION

"BOBO MAKE SOME SERIOUSLY BEAUTIFUL TRANSPARENT FURNITURE."

BoBo is the Brighton based contemporary design company particularly recognised for its innovative approach to furniture and spatial design with a specialism in the application of acrylic materials. The predominant force behind the progressive company are BoBo and the founders and directors Nick Gant and Tanya Dean.

Tanya and Nick have been working together since 1996, officially in 1997. They both graduated on BA Hons courses at the University of Brighton on 3D Craft and Design for Production and at Central St Martins on Product Design but also lecture nationwide to students and design professionals.

Although relatively young as a company BoBo have evolved their craft training and have designed and execute a diverse range of creative projects. These include commercial product design, interior architecture, creative marketing consultancy and production for retail and BoBo continue to satisfy a long and impressive list of high profile corporate and community clients.

Worldwide recognition from design and fashion press has allowed exposure on the international exhibition and marketing circuit putting BoBo in important positions as an identified innovator within the British contemporary design movement.

No.2.1 | INNOVATION PRODUCT

BoBo has launched over 50 different furniture products that have exceeded prototype stage. We hand make prototypes to a high finish sourcing inspiration from the materials and their qualities. We often thrive off the challenges that commercial constraints throw down, but always allow time to experiment through craft as well as technology. This cross process not only enables us to realise our creative aims but broadens our creative potential allowing manufactured stock to be produced alongside finely crafted one-offs. So whilst mass producing tailormade ranges for retail outlets like 'Liberty' and increasing the 'promotional product portfolio' of a company like 'Absolut Vodka', with stylised pieces we have still serviced clients like 'Vivienne Westwood' with fine-art pieces for couture catwalk shows.

RECENT EXHIBITIONS:

Homes of the Future - Glasgow City of Architecture 1999
100 years of Art and Fashion - Private view - Hayward Gallery London
The New York International Contemporary Design Show.
The London Contemporary Design Show - 100% Design.
The British and Design Festival - 'Fish and Chips' Stilwerk Hamburg.
The European Contemporary Product Fair - Frankfurt.
International Biennial Design Festival, St-Etienne.

CASE STUDY: AIRWAVE TABLE

Finalist - Blueprint Design Awards 1997.
Launched at 100% Design London 1997.

The AIRWAVE TABLE was born from a wish to create a powerful image of 3 dimensions and movement by simply placing together pure sheets of flat clear Perspex. We feel the result is a fusion of design expression and functionality. It requires no clues or screws and simply slots together producing a surprisingly strong structure. The AIRWAVE TABLE exploits the fantastic, unmatched clarity of clear Perspex to produce a magical vision of form.

11

No.2.2 | INNOVATION SPACE

No.3 | MATERIALS

"THE GREAT PLAY OF LIGHT THEY CREATE THROUGH THE USE OF GLASS AND UNUSUAL LINES AND THE SUPERB PROPERTIES OF THE PERSPEX, MAKES FOR EXCITING VIEWING, TOUCHING AND LIVING."

"BOBOS' SKILLED CRAFTSMANSHIP IS NOT ONLY APPARENT IN THE DESIGN BUT ALSO IN THE PAINSTAKING CARE INVOLVED IN EVERY OUTPUT. EVERY CORNER OR SMOOTHED SURFACE - THIS IS ULTRA SOPHISTICATED STUFF."
BEVERLY BROWN - EDITOR OF HOMESHOW MAGAZINE

One of the advantages of a small skilled team, that are connected to a large resource of materials knowledge and expertise, is that we are able to create complete environments. We have proven that country estates or international destinations... understanding of space, by completing entire interior projects for private and commercial clients. Complete project co-ordination enables precise detail refinement as well as large component installation without subcontracting costs.

"The BoBo team planned everything with military precision. Vibrant colours, clean lines and attention to detail are the key to a typical BoBo style. BoBo furniture would liven up any interior. Gant and Deans work is highly inventive."
June Ducas, Sunday Times Style Magazine.

No.3 | MATERIALS

At the heart of our creativity are the materials we use – although our portfolio catalogues a diverse range of projects; the backbone of all our work is our expertise in the application and manipulation of materials, particularly Acrylics. We use Perspex as a product because of the high quality of material that our work demands. Perspex as a material provides the foundation to our creativity and continues to inspire us.

The enthusiasm we share for our source materials has led to an almost fated relationship with ICI ACRYLICS creators of PERSPEX as well as other market leading brands such as PRISMEX, LUCITE and ULTRA. From an original sponsorship deal with Perspex we now consult directly to the brand managers as part of the marketing team. We contribute on all levels from technological and creative to commercial application for the full range of acrylic material products. Our experience and knowledge... specifically in the classic areas of Perspex as 'the' branded acrylic.

CASE STUDY: PRISMEX TECHNOLOGY

Light is of fundamental importance within our environment and Perspex in all of its forms helps a designer, architect or specifier to control this element within our visual world. A stunning new product under the Perspex umbrella is PRISMEX. Developed by Perspex and Phillips it uses a dot matrix surface system to allow amazing transmission of even, bright and cool light across a sheet of Perspex.
BoBo have been key to the promotion of Prismex to designers and architects in its vital early stages as a material product. We have worked closely with the team in charge of Prismex to learn more about its technicalities before taking some radical approaches to experimenting with its potential. The result has opened up new avenues for the material and enabled us to generate some exciting product designs of our own – embracing the new material technology – (launched at 100% Design 1999) We took the first steps into the field of experimenting with the enthusing new material and have created three dimensional illuminated, transparent forms. The 'Prismex table', 'Blow seating' and 'Sail' sculptural Lights are vehicles to transport the information regarding the potential of Prismex as an environmental lighting tool and indicate the powerful effect that Prismex will have on the future of illumination.

Nick Gant and Ian Williamson -Technical Manager, ICI Acrylics

Frames created for the promotion of new 'metallic' Lucite materials

Tanya -Creating the first blown Prismex sheet

In a nice reversal of the way text bubbles are used in cartoon strips, here the images (photographs) are surrounded by a border and connected to the text with a tapering leader line.

No.4 | THINKING

"THE CURVES OF THE BOBBIN CD RACK ARE VOLUPTUOUSNESS
ITSELF. THE PILLOWSHAPES OF THE AIRWAVE TABLE
PRESENT A SOFTNESS OF SHAPE TOGETHER WITH A
DELICATE REFLECTION OF ENERGY AROUND THE PIECE:
FURNITURE AS SCULPTURE."
BEVERLY BROWN - EDITOR OF HOMESHOW MAGAZINE

BoBo as a company turns ideas and creative thinking into reality.
The beauty of designing within three dimensions is the physical
presence of an idea realised —its use as an object for sensory
stimulation and/ or to execute a specified function. Often though
a piece can imply a concept far bigger than the than the object
itself. Working within the realms of continuous development
and promotion for our different areas of activity, it is obvious how
important creative skill is to progress the future. Applied design
can inspire new employees to realise these ideas but also to
ideas. BoBo of is at the way we, at the heart of everything we do.
inspire new and applied design.

Art, ideas and drawings absolutely everyone has, but we use ours to provide up with a way of life
based around design — they are at the heart of everything we do. They always be about us as a team
our personal creativity... at the way we think and develop as people.

No.4 | THINKING

CASE STUDY: THE 100% DESIGN PARTY 1999 IN ASSOCIATION WITH THE V&A MUSEUM AND ICI PERSPEX

The drawings featured depict the working process of objects that were designed to promote some of the amazing
possibilities when using Perspex as a constructive material. The giant objects contain figures for display at the
London Contemporary Design Show at the Millennium year 'Party 100' curated and hosted by the Victoria and
Albert Museum. BoBo asked "The New Renaissance's Creators or many amazing Perspex objects and music
videos, to help develop the giant pieces that celebrate architecture and the millennium through the utilisation
of Perspex. The objects were created to inspire the hundreds of design professionals and VIPs at the event and to
communicate the value of Perspex as a creative tool. This project illustrates how BoBo developed and coordinated
a marketing concept that unlocked the events potential as a business promotion whilst providing a stunning handcrafted
backdrop for this important occasion.

Designers
Mark Allen, Dave Bravenec,
Adrianne De Loia, Armando
Llenado, Chris Martinez

Art Director
Dave Bravenec

Illustrators
Dave Bravenec, Adrianne
De Loia, Alejandra Jarabo

Photographer
Dave Bravenec

Design Company
Kick Media

Country of Origin
USA

Description of Artwork
Stationery for C14 Design,
the creative laboratory of
Kick Media.

Dimensions
Sticker (*below left*),
Business card (*below
right, top & bottom*):
115 x 51 mm, 4¹/₂ x 2 in
Postcards (*opposite*):
153 x 102 mm, 6 x 4 in

Format
Corporate identity

C14 Design

The strong graphic identity of this design group has two simple elements:
a black C14 logo-type and the second-color hippopotamus. Two-color printing
is used to maximum effect (*below*), with the second color appearing in three
different percentage tints, and text reversed white-out-of-green in contrast
to the black text used elsewhere. The postcards (*opposite*) immediately
identify the company through its name and the hippopotamus, showing that
consistent use of a word or symbol can identify, even when their connection
to the activity of a company is not immediately obvious.

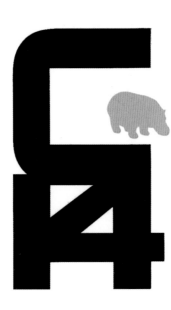

carbon14

Dave Bravenec
Creative Director
dbravenec@carbon14.net
310.314.6713

carbon14

320 Sunset Avenue
Venice, CA 90291
310.392.8282
310.314.6712 fx
www.carbon14.net

This side of the business card reveals how the varied use of the second
color can produce a degree of subtlety within a bold design.

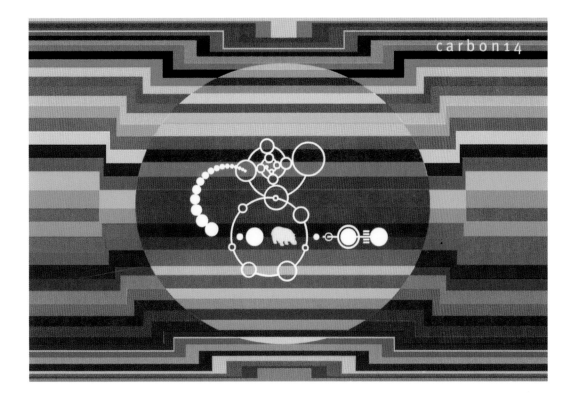

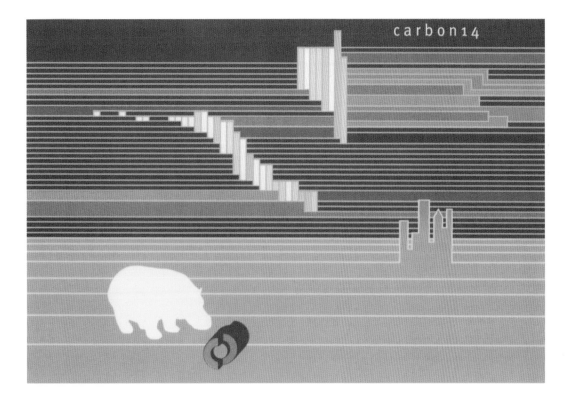

C14 mostly use the hippo symbol in a purely abstract way. However, on this postcard, its use is more directly linked to the design: it seems to be looking at the cylindrical object—which increases its flexibility and adds a touch of humor.

Thomas & Bohannon Stationery

Everything about this range of stationery has been inspired by tools of the printing trade—a simple idea, nicely executed. The centerpiece of the design is an industrial-catalog-style line drawing of a printing press which acts as the company logo. In addition, a number of graphic devices, all part of the printer's lexicon—crop marks, registration marks, density panels, and guide rules—work to produce a distinctive and extensive stationery range. The resulting design communicates a sense of specialist expertise and attention to detail that is a very good promotion of the company to potential clients.

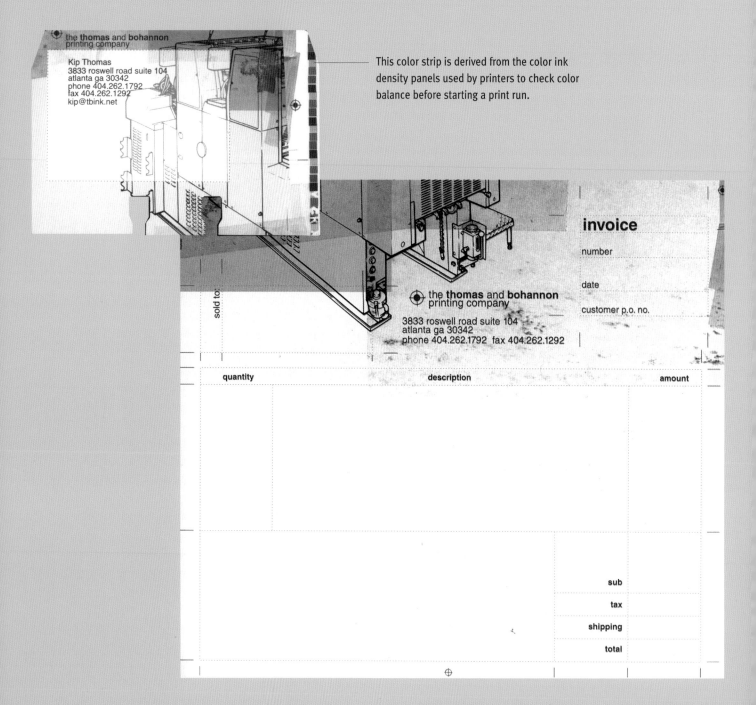

the **thomas** and **bohannon**
printing company

Kip Thomas
3833 roswell road suite 104
atlanta ga 30342
phone 404.262.1792
fax 404.262.1292
kip@tbink.net

This color strip is derived from the color ink density panels used by printers to check color balance before starting a print run.

the **thomas** and **bohannon**
printing company

3833 roswell road suite 104
atlanta ga 30342
phone 404.262.1792 fax 404.262.1292

invoice

number

date

customer p.o. no.

sold to

quantity	description	amount
	sub	
	tax	
	shipping	
	total	

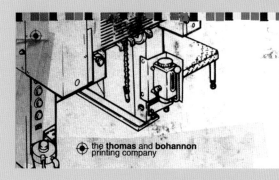

Crop marks, normally used to show where to trim the printed sheet, are used here to play with the space on the page by demarcating the area in which to type or write.

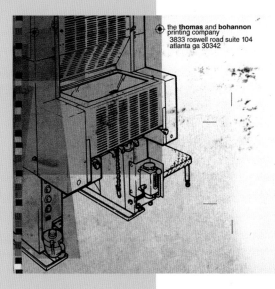

the **thomas** and **bohannon**
printing company
3833 roswell road suite 104
atlanta ga 30342

Designers
Graphic Havoc avisualagency

Illustrators
Graphic Havoc avisualagency

Design Company
Graphic Havoc avisualagency

Country of Origin
USA

Description of Artwork
Corporate identity package,
including 'logo,' stationery,
and website, for an offset
lithography printing company.

Dimensions
Various

Format
Corporate identity

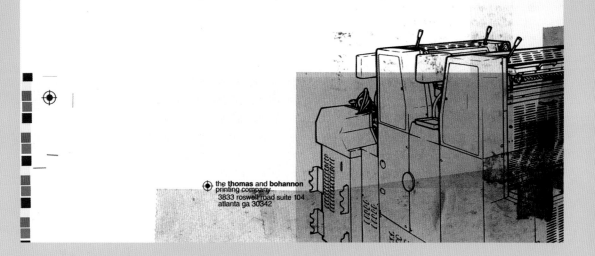

the **thomas** and **bohannon**
printing company
3833 roswell road suite 104
atlanta ga 30342

Designers
David Hand (*below*, *left*)
Seel Garside (*below*, *center*)
Hitch (*below*, *right*)
Ian Mitchell (*opposite*)

Design Company
Beaufonts

Country of Origin
UK

Description of Artwork
A set of posters featuring
fonts created by Beaufonts.

Dimensions
297 x 420 mm
11³/₄ x 16¹/₂ in

Format
Poster

Don't Panic—This is Beaufonts

Advertising typefaces is not easy, as they are often required to be
the unobtrusive building blocks of design. Here, Beaufonts' simple
but witty posters serve their purpose very well, not only to promote
their type library but also the company and its website. They succeed
in promoting very different font styles by using disparate but always
intriguing images together with recurring areas of flat color that give
visual cohesion to the promotion.

Special Production Techniques

Designed specifically to be downloaded from their website, these
posters have never been traditionally printed.

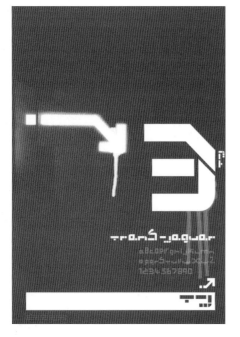

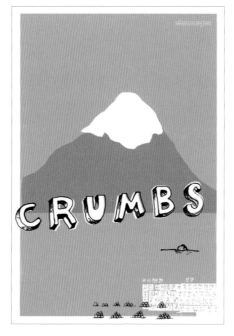

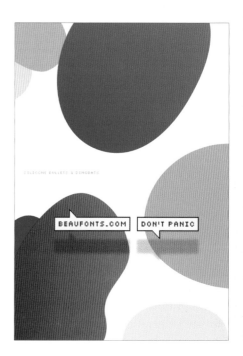

www.beaufonts.com

[letterforms, symbols, ideas and interaction]

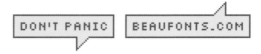

DON'T PANIC BEAUFONTS.COM

Chercher/Trouver (Looking For/Finding)

Interesting self-promotion is achieved here without showing any of the designer's work. Instead, the activities of the group are presented conceptually. This book has been created alongside their website and therefore has been strongly influenced by it. The use of geometric line imagery creates a background texture upon which the text is overlaid. The central information bar acts as a stable backbone against which the other elements are varied and contrasted.

Opposite, center: the fluid background design successfully evokes movement, which is a key element of the accompanying interactive website.

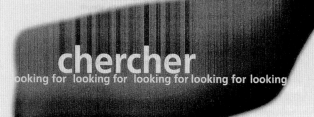

Designer
Agraphe

Art Director
Thomas Erhel

Copywriters
Laetitia Campana, Thomas Erhel, Luis Mizon

Illustrator
Ludovic Erhel

Photographer
Computer images and photographs by Agraphe

Design Company
Agraphe

Country of Origin
France

Description of Artwork
28-page self-promotional book

Page Dimensions
210 x 210 mm
8¹/₄ x 8¹/₄ in

Format
Book

UNE COMMUNICATION DYNAMIQUE C'EST CRÉER DES POINTS DE CONTACT AVEC SENSIBILITÉ
des signes et des formes
 DYNAMIC COMMUNICATION IS CREATING CONTACT POINTS USING SENSITIVITY
 signs and forms

| EDITION | LOGOTYPES | IDENTITÉ VISUELLE | DESIGN PUBLICITAIRE | TYPOGRAPHIE | IMAGES NUMÉRIQUES | AGRAPHE |
| publishing | logotypes | visual identity | advertising design | typography | computer images | |

graphic design

In a world saturated with images and information, you are read before being read. We must find and highlight what makes you different from the others. — TRANSFORM, IMPROVE, REINFORCE! Considering that the logo and the graphic charter constitute the foundations of the visual identity of the company, you must also continuously develop and adapt your image.

Our priority is to work with you, advising you and ensuring the resonance of this change. A complete production in which words and images create the event.

design graphic

Dans un monde saturé d'images et d'informations, vous êtes lu avant d'être lu. Il s'agit de trouver et de mettre en avant ce qui vous distingue des autres. — TRANSFORMER, AMÉLIORER, RENFORCER! Considérant que le logo et la charte graphique constituent les fondements de l'identité visuelle de l'entreprise, il faut la développer et l'adapter en permanence votre image.

Notre objectif consiste à être à vos côtés et à vous conseiller et d'assurer avec vous la résonance de cette évolution. Toute une réalisation où le mot et l'image créent l'événement.

IL VEUT DESSIN DE COMPOSITION
le sens des sons
 senses of sounds
AMENER AU DÉSIR EN DONNANT DU SENS NE PAS CHERCHER À ILLUSTRER, MAIS RACONTER

| DESIGN CD | PACKAGING | COLLECTION | AGRAPHE |

design CD & packaging

As a true expression group, the conception of a CD is an essential exercise for us. It enables us to continuously develop and update our graphic skills: the ability to analyse, culture of image, of colours and of typographic, as well as our knowledge and expertise of printing techniques using a variety of formats and on different mediums (posters, POS, press ads, etc...). Working on strong identity products.

design CD & packaging

Véritable champs d'expression graphique, la conception d'un disque est pour nous un exercice nécessaire. Il nous permet de développer et d'actualiser en permanence nos compétences graphiques: capacité et rapidité d'analyse, culture de l'image, de la couleur et de la typographie, ainsi que nos connaissances et notre maîtrise des techniques d'impression dans différents formats et sur différents supports (affiche, plv, annonce presse, etc...). Un réel travail sur des produits à forte identité.

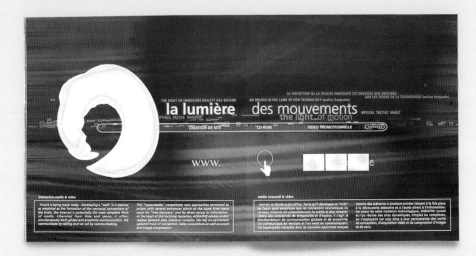

LA PERCEPTION DE LA RÉALITÉ IMMÉDIATE EST DEVENUE UNE ORCHIDÉE
THE SIGHT OF IMMEDIATE REALITY HAS BECOME AN ORCHID IN THE LAND OF NEW TECHNOLOGY (walter benjamin)
 SUR LES TERRES DE LA TECHNOLOGIE (walter benjamin)
la lumière des mouvements
OPTIQUE TACTILE MAGIQUE OPTICAL TACTILE MAGIC
 the light of motion

| CRÉATION DE SITE | CD-ROM | VIDÉO PROMOTIONNELLE | AGRAPHE |

www.

interactive media & video

- Future is being made today - Developing a "web" in a manner as empirical as the formation of the neuronal connections of the brain, the internet is potentially the most complete form of media. Liberated from time and space, it offers simultaneously both global and proximity communication. We communicate by selling and we sell by communicating.

This "hypermedia" necessitates new approaches conceived as scripts with several entrances which at the same time leave room for "free discovery" and for direct access to information. At the heart of this technical mutation, AGRAPHE advises and/or realizes dynamic sites, simple or complex. We rely on permanent updated tools of conception, video acquisitions as well as sound and image compression.

media interactif & vidéo

- demain se décide aujourd'hui - Parce qu'il développe sa "toile" de façon aussi empirique que les connexions neuroniques du cerveau, internet est potentiellement le média le plus complet. Libéré des contraintes de temporalité et d'espace, il s'agit là simultanément de communication globale et de proximité. On communique en vendant et l'on vend en communiquant. Cet hypermédia nécessite donc de nouvelles approches conçues

comme des scénarios à plusieurs entrées laissant à la fois place à la découverte aléatoire et à l'accès direct à l'information. Au cœur de cette mutation technologique, AGRAPHE conseil et / ou réalise des sites dynamiques, simples ou complexes, en s'appuyant sur une mise à jour permanente des outils de conception, d'acquisition vidéo et de compression d'images et de sons.

Fuel Printed Matter

(See following spread for description)

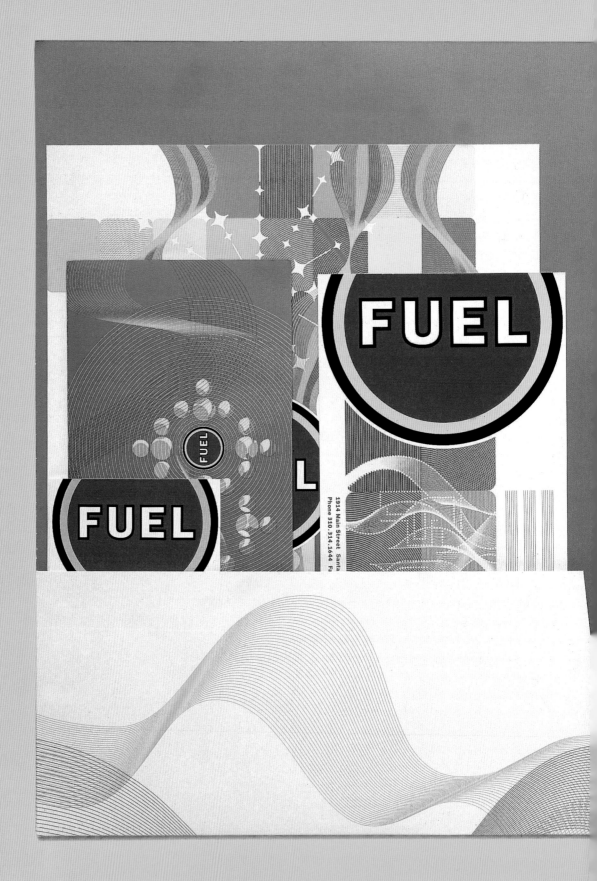

Fuel Printed Matter

(See following spread for description)

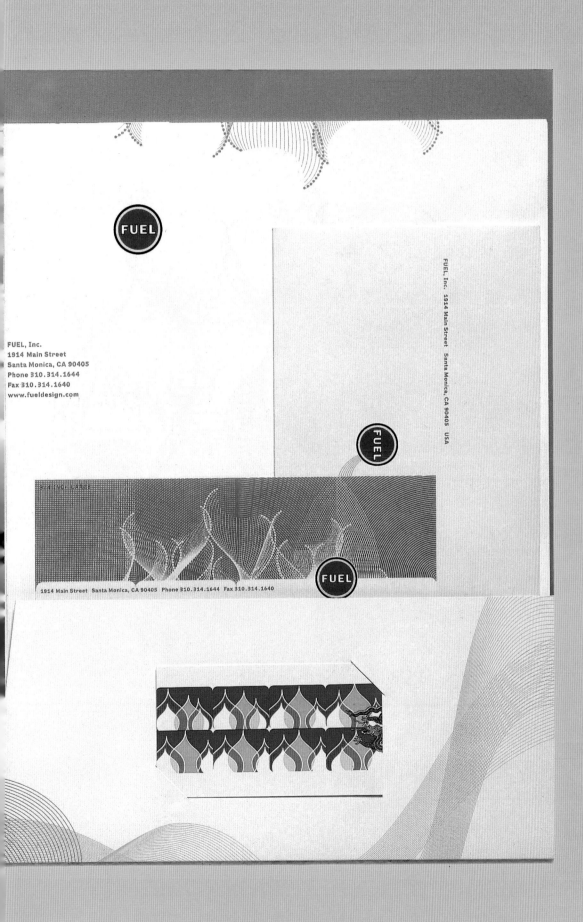

FUEL, Inc.
1914 Main Street
Santa Monica, CA 90405
Phone 310.314.1644
Fax 310.314.1640
www.fueldesign.com

FUEL, Inc. 1914 Main Street Santa Monica, CA 90405 USA

1914 Main Street Santa Monica, CA 90405 Phone 310.314.1644 Fax 310.314.1640

Designer
Jens Gehlhaar

Creative Director
Seth Epstein

Illustrator
Jens Gehlhaar

Design Company
Fuel

Country of Origin
USA

Description of Artwork
A range of stationery and packaging, including video labels and inserts, for the Santa Monica based motion graphics studio Fuel.

Dimensions
Various

Formats
Stationery, packaging

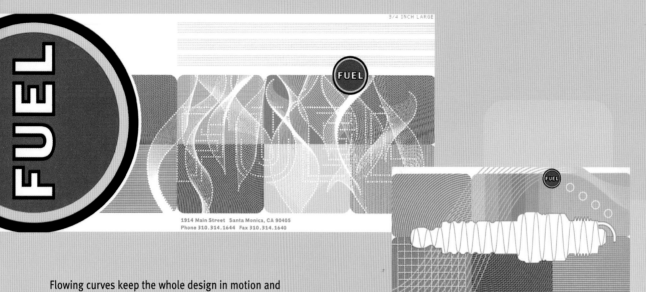

1914 Main Street Santa Monica, CA 90405
Phone 310.314.1644 Fax 310.314.1640

Flowing curves keep the whole design in motion and
reinforce the dynamic nature of the company's output.

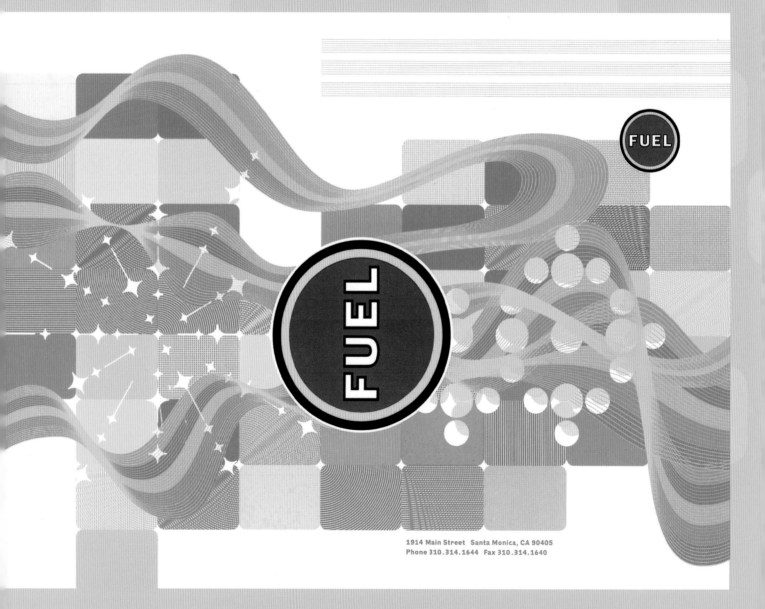

1914 Main Street Santa Monica, CA 90405
Phone 310.314.1644 Fax 310.314.1640

Fuel Printed Matter

Taking its inspiration from the company's name, the designer's intention was to 'express very television-specific ideas, such as energy and motion, with very print-specific means, such as metallic inks and intaglio vector art.' The simple boldness of the logo and consistent use of color gives a strong and instantly recognizable visual identity to a wide range of stationery. The use of metallic ink enhances the visual feel by contrasting bright colors against flat metallic gray, while the 'intaglio vector art,' which hints at bank-note currency, adds a subliminal value.

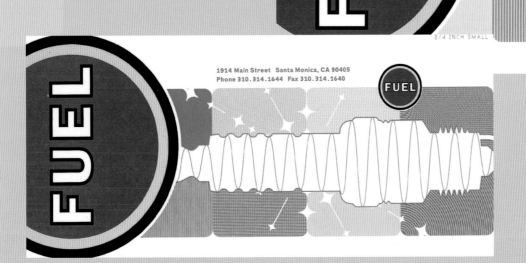

The outline of a spark plug is used to extend the analogy with engine technology and to suggest creative inspiration.

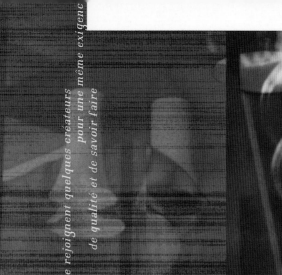

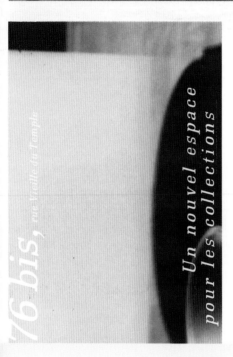

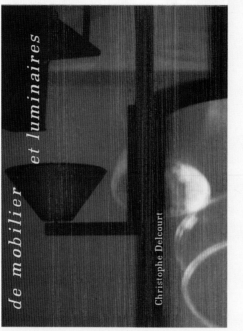

76 bis, rue Vieille du Temple

Un nouvel espace
pour les collections

de mobilier et luminaires

Christophe Delcourt

Le rejoignent quelques créateurs
pour une même exigenc[e]
de qualité et de savoir faire

pour des intérieu[rs]
d'aujourd'hui...

Christiane Perrochon / Pietro Seminelli
Isabelle Roux / Françoise Dor[…]
David David / François Champsaur

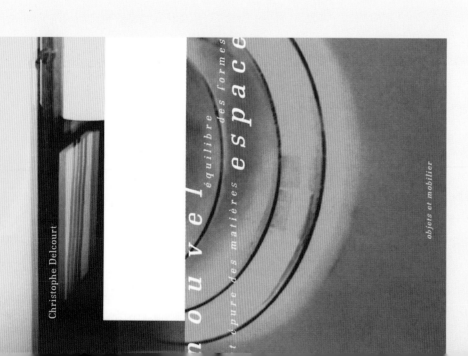

Christophe Delcourt

n o u v e l espace
équilibre des formes

[…]t[…] pure des matières

objets et mobilier

The play of forms within a space is central to this
furniture designer's thinking and this is reflected in
the way that the page area has been divided and
intersected by areas of white.

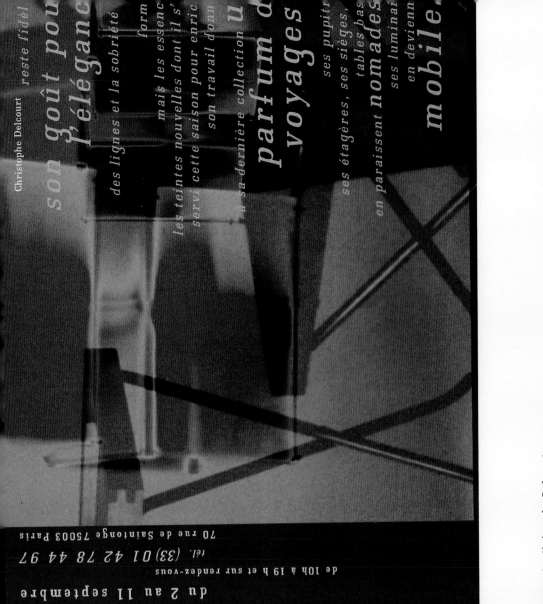

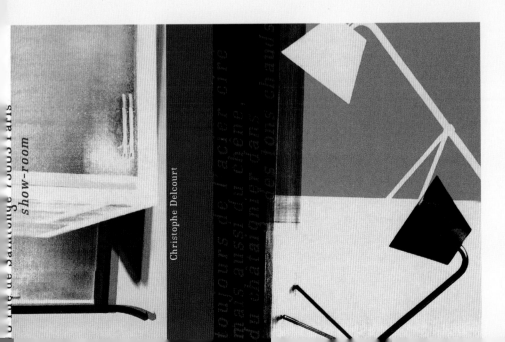

'New Room'—Christophe Delcourt

The choice of two-color printing and the layering of abstract photographic imagery creates a subtle yet sophisticated style that matches that of the furniture and lighting on show. The delicate typography on the covers of the folded invitations (*left, above & opposite*) is developed inside and combined with a narrow color range that reflects the materials used by the furniture designer.

Designer
Philippe Savoir

Art Director
Philippe Savoir

Design Company
Filifox

Country of Origin
France

Description of Artwork
Invitations to view the work of furniture and lighting designer Christophe Delcourt

Page Dimensions
180 x 215 mm
7¹/₈ x 8¹/₂ in

Format
Invitation

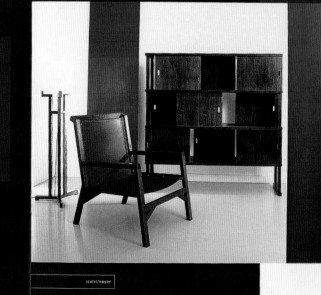

Designer
Philippe Savoir

Art Director
Philippe Savoir

Photographer
Patrice Degrandry

Design Company
Filifox

Country of Origin
France

Description of Artwork
24-page catalog of furniture
and lighting design by
Christophe Delcourt.

Page Dimensions
210 x 260 mm
8$^{1}/_{4}$ x 10$^{1}/_{4}$ in

Format
Catalog

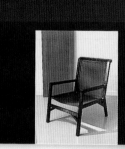

627 bibliothèque
BET..............................

515 lampadaire
NUI..............................

629 fauteuil
NUO..............................

:C1—Christophe Delcourt

The clean lines and style of the furniture and lighting featured in this publication are mirrored in the clear, geometric approach taken to its layout. This aesthetic is extended to the typography which is sparse and tightly controlled. The uncluttered structure of the spreads gives prominence to the elegant richness of the dark wood and leather furniture, strikingly displayed in pristine settings.

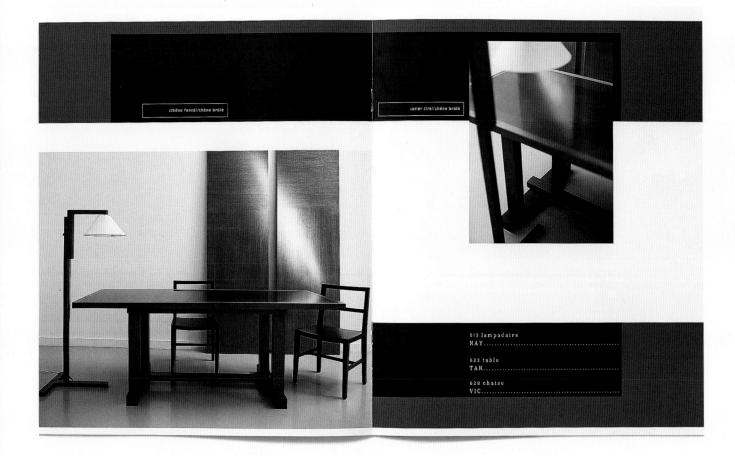

:chêne foncé//chêne brûlé

:acier ciré//chêne brûlé

513 lampadaire
HAY.....................................

623 table
TAR....................................

620 chaise
VIC....................................

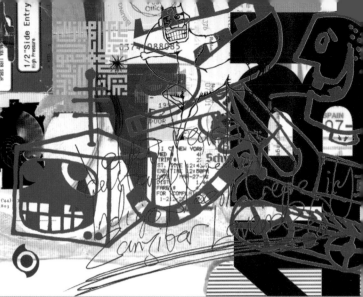

Designer
Mark Caylor

Art Directors
Rob O'Connor, Mark Caylor

Illustrator
Mark Caylor

Design Company
Stylorouge

Country of Origin
UK

Description of Artwork
Corporate identity for use on a
coordinated range of stationery.

Dimensions
210 x 99 mm
8$^1/_4$ x 4$^1/_2$ in

Format
Stationery

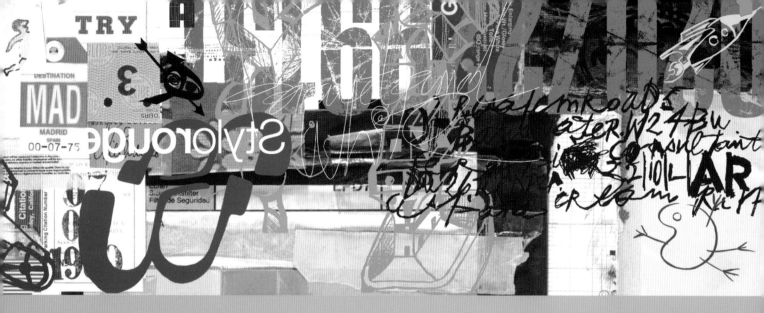

Creative Consultants
6 Salem Road London W2 4BU UK **Tel** +44 (0)20 7229 9131 **Fax** +44 (0)20 7221 9517
E-mail: mail@stylorouge.co.uk Stylorouge on line: http://www.stylorouge.co.uk ISDN (0)20 7221 5803

Stylorouge.

Stylorouge Corporate ID

The diverse nature of Stylorouge's work for the music industry is
reflected in the component parts of the image: found typography
and pictures, drawings, graffiti, labels, and tickets suggest their eclectic
influences. This polyphony of visual languages, reminiscent of a
flyposted city wall, stands in stark contrast to the simplicity and clarity
of the logo-type and gives this self-promotional work its strong identity.

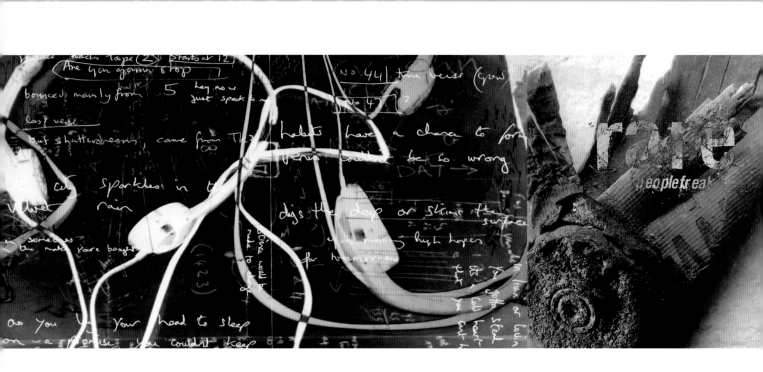

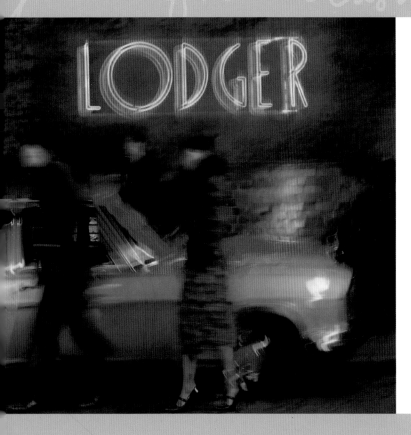

Portfolio #1

This bold presentation of design work for the music industry makes no concessions to the viewer. The abstract images are without explanation, and therefore stand or fall by their visual references and integrity. Whether the work is familiar or not, the choice of imagery suggests the theme being promoted.

Designers
Rob Crane, Martin Yates

Art Directors
Rob Crane, Martin Yates

Photographers
Top: Alex Hanson, Lucky Morris
Bottom: Stuart Weston

Design Company
Satellite

Country of Origin
UK

Description of Artwork
A collection of design work for the music industry compiled as a promotional portfolio.

Page Dimensions
213 x 155 mm
8³/₄ x 6¹/₈ in

Format
Book

Ogier Stationery

With the type on one side and the image on the other, this slightly
costly but engaging twist is an elegant solution to the job. The obscure
shapes (parts used in the construction of the lighting sold in Ogier,
a contemporary furniture shop) are carefully positioned on the
letterhead to be the first thing seen when the envelope is opened.
They not only give a feel for the products but also add an enigmatic
touch that is in keeping with the whole design approach.

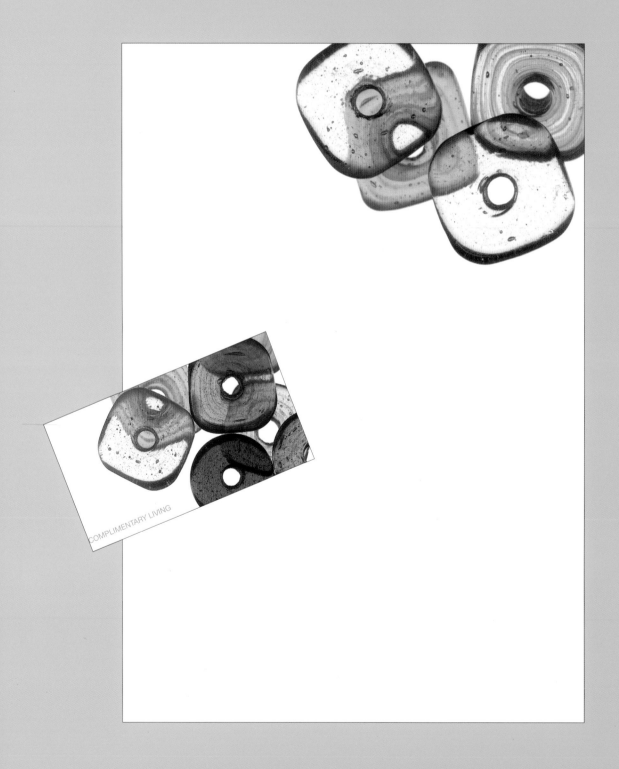

COMPLIMENTARY LIVING

Designer
Mark Rogerson

Art Director
Mark Rogerson

Photographer
Jonathan Brade

Design Company
Mark Rogerson Associates

Country of Origin
UK

Description of Artwork
Stationery designed for Ogier,
a contemporary furniture shop.

Dimensions
Letterhead: 210 x 297 mm
8¹/₄ x 11³/₄ in
Business Card: 90 x 50 mm
3¹/₂ x 2 in

Format
Stationery

OGIER

COMPLIMENTARY LIVING

177 WESTBOURNE GROVE, LONDON, W11 2SB
TELEPHONE: 0207 229 0783, FACSIMILE: 0207 221 8276
E-MAIL: OGIER@DIRCON.CO.UK

YVES OGIER

OGIER

177 WESTBOURNE GROVE, LONDON, W11 2SB
TELEPHONE: 0207 229 0783, FACSIMILE: 0207 221 8276
E-MAIL: OGIER@DIRCON.CO.UK

Scintpreen/Preenscint

(See following spread for description)

ʇuᴉɔspreen

Designer
Jens Gehlhaar

Illustrator
Jens Gehlhaar

Country of Origin
USA

Description of Artwork
36-page book about the
changes the graphic design
profession faces with the
advent of new media. Text
by Jens Gehlhaar.

Page Dimensions
203 x 257 mm
8 x 10 in

Format
Book

While the accomplishments of the visual collaborators may be highly celebrated and compensated,

the ability to launch current and future projects rests with the authors — the directors and screenwriters."

"That was then, and this is now: but was is next?", Emigre, № 39, 1996, p 26

Lorraine Wild

"[...] the process of large group or team projects in multimedia has less to do with the division of labor in print production, and is much more akin to collaborative enterprises, such as theatrical production, TV production, or movie-making in the entertainment industry. And in those enterprises, the identity and independence of individuals responsible for the visual presentation [...] are secondary in both the hierarchy of production and in the point of view of the audience to the vision or authorship of the director (and perhaps the screenwriters).

26°

Lorraine Wild

"...in new media, the connection between content and its presentation is so tight that there is barely any conceptual space in which to see a separate need for development of the visual independent from the verbal."

"That was then, and this is now: but was is next?", Emigre, № 39, 1996, p 26

New media seems to open up a whole new set of possibilities for the design profession on its quest for more respect. The structural aspect of design (in print: the functionality of the book format, the organization of information, the interactivity of forms) becomes more visible on the screen and is discussed by the public on a bigger scale. While in print a variety of standardized and well-tried media like brochures, flyers, folders, magazines etc. are at the designer's disposition, allowing him to take the user's familiarity with these media for granted, in interactive media with every new project a new sub-medium has to be invented. ¶ Right now, there is not much more than either a web site or a CD ROM. The web itself is just defined by – as the name suggests – its own connectedness and its boundlessness. A CD ROM is a technical term for 650 MB of data storage. As of now, neither a website nor a CD ROM is a culturally defined medium that is associated with notions of specific purposes or the amount of time it takes to go through it. ▲ As long as there are no scales defined, the creation of the medium itself – manifested in its naviga–tion and the logic of its map – is a highly visible and interesting problem. ¶ If with every new digital work at the beginning the user has to learn how to navigate, then the design will never become as invisible as it is supposed to be in other traditionally structure-heavy areas like user's manuals or forms. In consequence, in new media the design becomes noticed more.

¶ Like exotic bindings, extravagant inks and technical gimmicks like punches or embossing get noticed even by non-professionals, in new media every user interface which goes beyond the traditional models of Macintosh or Windows desktops will be regarded as an innovation, an invention ▲, as a design product – and of course gets criticized if it fails. The creation of the structure now demands a serious amount of the design process and shifts its emphasis from semantics to syntax. In print we can take the various media for granted and use them as an empty canvas we create our design on – in new media we have to create the integral functionality of the medium and run out of time when it comes to take care of the soft, intuitive aspects that enrich the meaning but don't have an impact on the function. ¶ For many designers, the option for a new level of attention makes the new media a promised land, where the graphic designer is respected as an important contributor to the finished work. At the same time, new media, with its stress on structural aspects, seems to be regarded as a place of refuge for those who have problems with contemporary degenerated or multi-layered design and are looking for an intact world to start all over ←

19° 19°

Maybe the boundlessness of digital media – previously regarded as its virtue – becomes its downfall. Would you pay $14.99 for a music CD if you wouldn't be sure that you are getting at least 45 minutes of music? Would you decide to watch a feature film if there would be a chance that it maybe is six hours long?

♫ There is an interesting tension within the design profession between the notions of invention and design. The invention of folding techniques or other technical or marketing innovations in print is often seen with suspicion, because they usually are connected with high production and precious luxury products, or disregarded as a gimmick that weakens the rest of the design. At the same time, non-professionals love these things. The notion of the inventor-designer seems much more fitting to industrial design, where the invention of form often leads to a new kind of product.

"[...] at Emigre, [...] as we're trying to deal with the new technologies that surround us, we see more use for the teachings of the young Jan Tschichold: communication must appear in the briefest, simplest, most urgent form."

"Graphic design and the Next Big Idea", Emigre № 39, 1996, p 11

Rudy VanderLans

On the other hand, those who had a share in the blame for degrading the old world, and are now bored by both the (apparent) exhaustion of possibilities and the inherent limitations of print may regard new media as a welcome change and a new challenge. Of course, they are missing that – as I mentioned above – there is a need for a re-definition of print, the working out of its integral advantages, as well as the opportunity to disprove the exhaustion theory ←

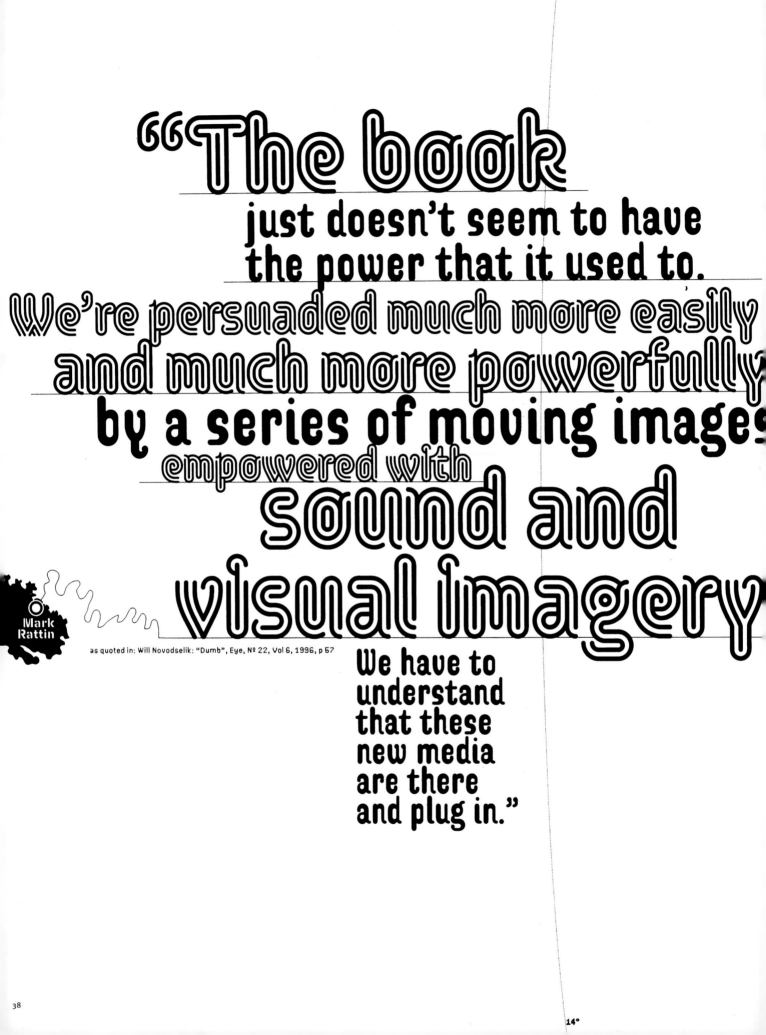

"The book just doesn't seem to have the power that it used to. We're persuaded much more easily and much more powerfully by a series of moving images empowered with sound and visual imagery.

We have to understand that these new media are there and plug in."

as quoted in: Will Novodselik: "Dumb", Eye, № 22, Vol 6, 1996, p 57

Mark Rattin

Scintpreen/Preenscint

Using the metaphor of the discovery of the Americas, this book
boldly explores the impact of new digital media on graphic design.
Imaginative and complex typography has been used to great effect,
overcoming the limitations of the one-color printing. Each spread
holds a surprise that keeps the viewer engaged with the text, while
the way in which the layout responds to the book's central metaphor
sustains this typographic journey through to the end.

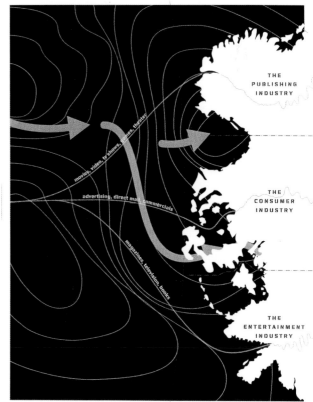

Scrapbook 2

This unashamedly personal piece of work not only gives an insight into the space the designers choose to work in, but also shows how they utilize space on the page. Although the snapshot style of photography is quite obscure, it succeeds in conveying a strong sense of the atmosphere in the building. Pleasing and quirky, the combination of informal photography and found imagery draws the reader in to this unobtrusively bilingual brochure.

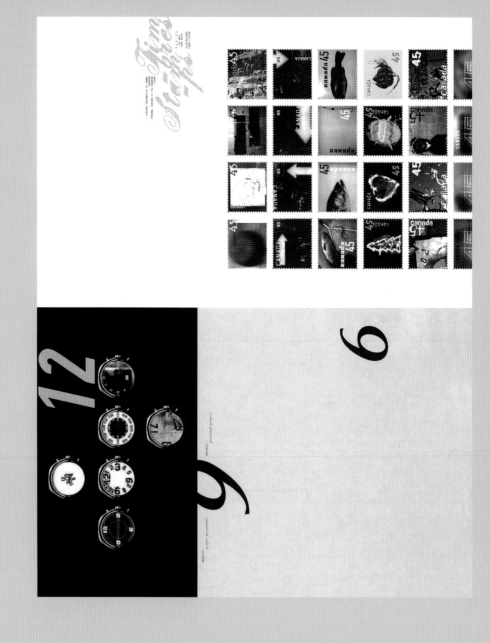

Designers
Pol Baril, Denis Dulude

Art Directors
Pol Baril, Denis Dulude

Photographers
Various

Design Company
KO Création

Country of Origin
Canada

Description of Artwork
Self-promotional brochure for KO Création, a graphic design studio.

Page Dimensions
280 x 435 mm
11 x 17 in

Format
Brochure

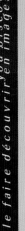

...look pretty special designers

ticuliers pour choisir comme

to pick this studio, located on

endroit de prédilection ce studio

the 4th...

situé au 4e étage d'une...

imprimerie. Mais il fallait...

un endroit bien particulier...

special place to inspire us d...

nous inspirer jour après jour...

after day... The many questions

Les nombreuses questions que

new visitors ask about our

notre studio suscite chaque fois

qu'un nouveau visiteur y met les

studio made us think of letting

pieds nous ont donné l'idée de

you discover it in pictures.

vous le faire découvrir en images.

Designer
Joseph Eastwood

Art College
University of Salford

Country of Origin
UK

Description of Artwork
An experimental typographic
reconstruction of the Bible.

Page Dimensions
120 x 170 mm
$4^3/_4$ x $6^7/_8$ in

Format
Book

Bible Reconstruction
The Bible must be one of the world's most printed texts, and yet
this reconstruction succeeds in drawing the reader in afresh. It is
particularly impressive that such an alluring and intriguing treatment
should be created out of two colors and pure type—economical and
a testament to the power of typography.

thegospelaccordingtost.luke.

CHAPTER 7.
THE GOSPEL ACCORDING TO ST. LUKE.

1-1

F or as much ᵍ as many have taken in **hand** to set forth in order a *declaration* of those things which are most surely *believed* among us,

For as much ᵍ as many have taken in **hand** to set forth in order a *declaration* of those things which are most surely *believed* among us, **2** Even as ¹ they delivered them onto us, which ᵏ from the beginning were ˡ eyewitnesses, and ministers of the word; **3** ⁿ It seemed good to me also,ᵒ having had perfect understanding of all things from the very first, to write unto thee ⁿ in order, ᵖ most excellent ᵠ Theophilus,**4** ʳ That thou mightest know the certainty of those things, wherein thou hast ᵇ been instructed. There was ᵈ in the days of **Herod**, the king of **Judaea**, a certain priest named *Zacharias*, ᵉ of the course of Abia: and his wife was of the daughters of Aaron, and her name was **Elisabeth**. **6** And they were both ᵍrighteous before **God**,ᵇ walking in all the commandments and ordinances of the **Lord** ᵇ blameless.**7** And they had no child, because that **Elisabeth** was barren, and they both were *now* ᵇ well stricken in years. **4** That thou mightest know the certainty of those things, wherein thou hast been instructed. There was ᵈ in the days of **Herod**, the king of **Judaea**, a certain priest named *Zacharias*, ᵉ of the course of Abia: and his wife was of the daughters of Aaron, and her name was **Elisabeth**. **6** And they were both ᵍrighteous before **God**, walking in all the commandments and ordinances of the **Lord** blameless.**7** And they had no child, because that **Elisabeth** was ᵇ barren, and they both were *now* ᵇ well stricken in years. **8** And they were both ᵍ righteous before **God**, walking in all the commandments and ordinances of the **Lord** ᵇ blameless.

ST. LUKE.

✠

here was ᵈ in the days of **Herod**, the king of **Judaea**, a certain priest named *Zacharias*, ᵉ of the course of Abia: and his wife was of the daughters of Aaron, and her name was **Elisabeth**.

1 And they were both ᵍ righteous before **God**,ᵇ walking in all the commandments and ordinances of the **Lord** ᵇ blameless. **2** And they had no child, because that **Elisabeth** was ᵈ barren, and ᵇ they both were now ᶠ well stricken in years.

3 For as much as many have taken in hand to set forth in order a declaration of those things which are ᵍ most surely believed among us,
4 Even as they delivered them onto us, which ᵏ from the beginning were ˡⁿ eyewitnesses, and ministers of the word; *5* It seemed good to me also,ᵒ having had perfect understanding of all things from the very first, to write unto thee ⁿ in order, most excellent Theophilus, *6* That thou mightest know the certainty of those things, wherein thou hast.ʳ been instructed.

THE GOSPEL ACCORDING TO ST. LUKE.
CHAPTER 1.

7 It seemed good to me also,ᵒ having had perfect understanding of all things from the very first, to write unto thee ⁿ in order, most excellent Theophilus,
8 That thou mightest know the certainty of those things, wherein thou hast.ʳ been instructed. most excellent Theophilus,

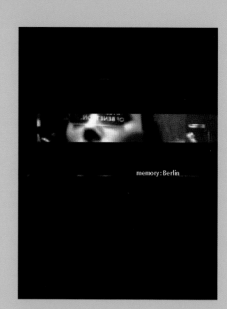

memory: Berlin

Designer
Esther Mildenberger

Art Directors
Esther Mildenberger, Brian
Switzer

Photographers
Esther Mildenberger, Brian
Switzer

Art College
Royal College of Art

Country of Origin
UK

Description of Artwork
A series of three books about
our perception of cities.

Format
Book

**Page Dimensions
(memory: Berlin)**
150 x 200 mm
5⁷/₈ x 7⁷/₈ in
Opening to a maximum width of:
300 mm, 11³/₄ in

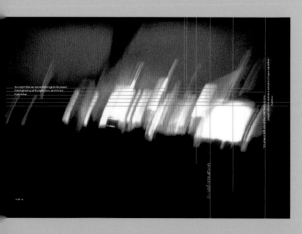

city: memory: Berlin, London, Tokyo—Book Projects, 1996–99
Part of an extensive project including videos and interactive
concepts, these three books (shown on this and the following two
spreads) share the same format and similar covers. Inside, the design
of the books is based on a personal interpretation of the cities, and
the way in which the pull-out construction and typography have been
used adds to the individual flavor of each publication.

memory: Berlin
In many ways the most straightforward in its layout, this book
uses abstract imagery and short texts to create a series of discrete
impressions. Typography features strongly in the imagery—murals,
fly posters, electronic signage—and this has been complemented by
keeping the caption texts compact and unobtrusive.

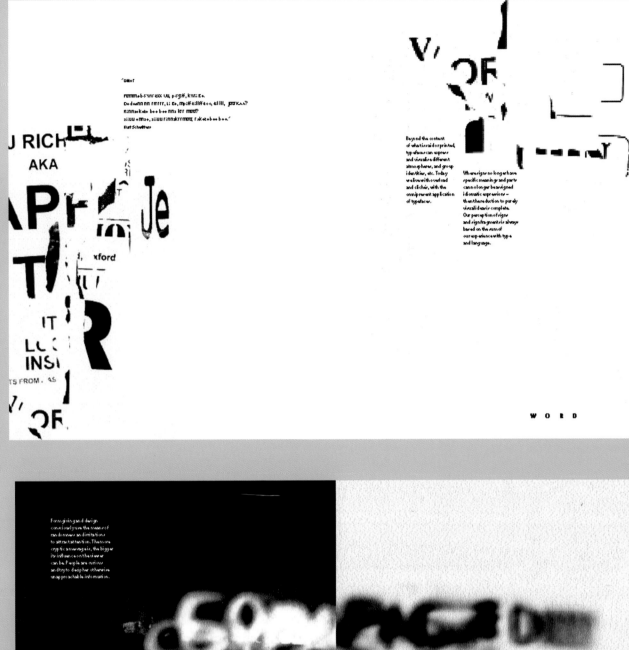

'Ueof

rummulo s-w-ezc uu, p-ogff, kwii ze.
De deuffl nn rrrrr, Li Ee, mpiff sillff eoo, si llll, ju KaA?
Rinnzekete bee bee nns krr muu?
sruu sernse, sruu rinnskrrmurg raketebee bee.'
Kurt Schwitters

Beyond the content of what is said or printed, typefaces can express and visualise different atmospheres, and group identities, etc. Today we focus without end and clichés, with the omnipresent application of typefaces.

Where signs no longer have specific meanings and parts can no longer be assigned idiomatic expressions – then the reduction to purely visual details is complete. Our perception of signs and significance is always based on the sum of our experience with type and language.

From giving and design consciously uses the means of randomness and limitations to attract attention. The more cryptic a message is, the bigger its influence on the viewer can be. People are curious and try to decipher otherwise unapproachable information.

'Poetry is possible in all signs and languages.'
Max Bense

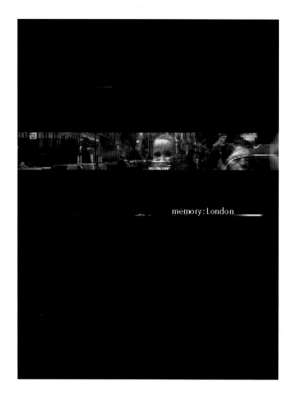

memory: London

The extended pull-out construction of this book has been used to create a sequential narrative of images and texts. Starting in restrained monochrome on the opening spreads, it progresses to the abstract, overlapping, and blurred imagery of the final color pages. The steady increase in the size of the squared-up photographs and the substantial blocks of text have been brought together into a formal yet asymmetric layout that gives a strong sense of how the designer responded to this city.

Page Dimensions
(memory: London)
150 x 200 mm
5⁷/₈ x 7⁷/₈ in
Opening to a maximum width of:
2,400 mm, 95 in

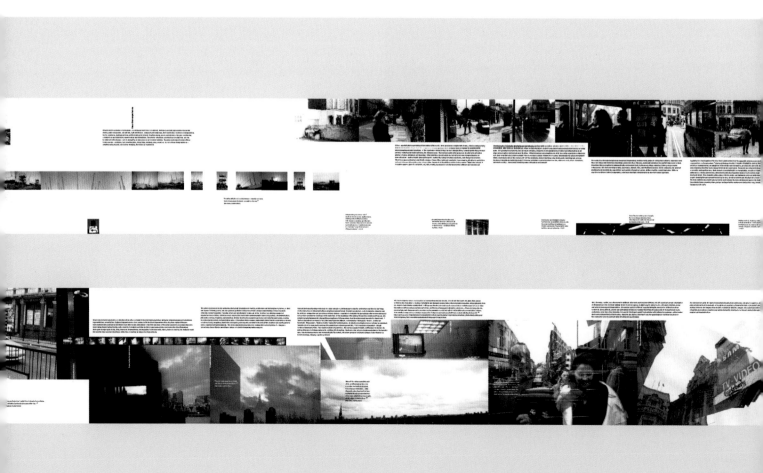

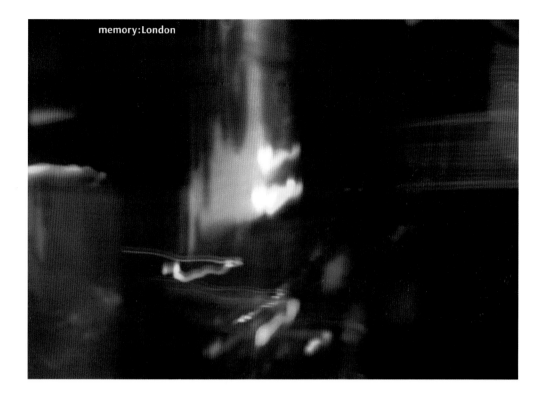

memory:London

At this stage in the visual narrative, the insertion of small
color images within an expanse of monochrome both
surprises and hints at what is to come.

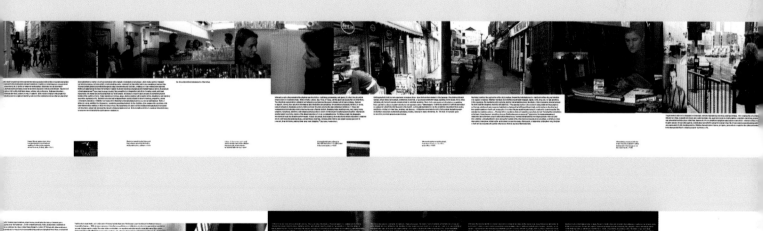

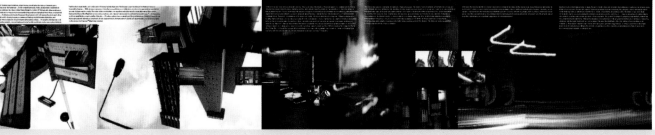

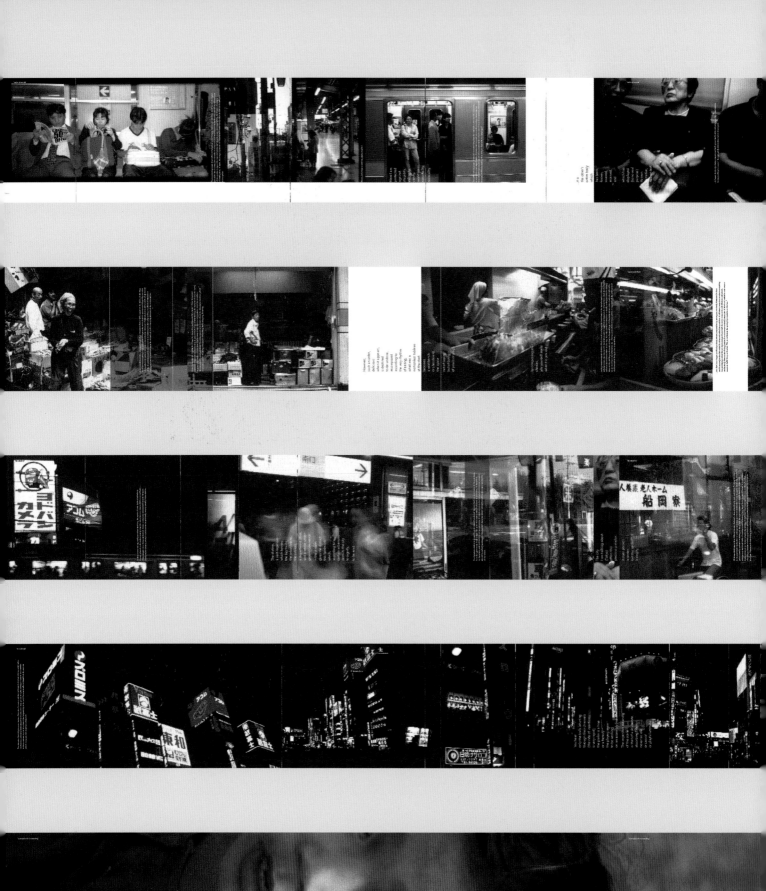

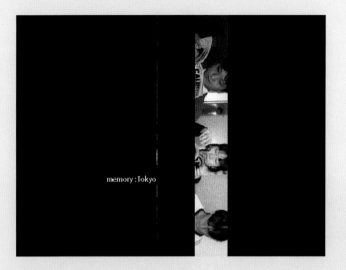

memory: Tokyo

With references to the layout of traditional Japanese calligraphic scrolls this designer has created friezes of imagery—sometimes out of separate images, sometimes one enormous picture—that play with the reader's sense of scale and intimacy. In contrast to this, the bulk of the text has been separated off and presented in a more formal way against the plain paper.

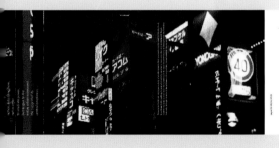

Page Dimensions
(memory: Tokyo)
150 x 200 mm
5⁷/₈ x 7⁷/₈ in
Opening to a maximum width of:
1,760 mm, 69 in

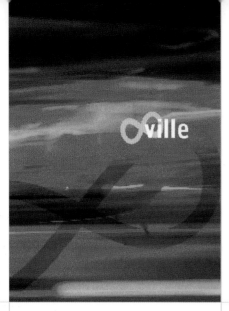

Designers
Esther Mildenberger,
Brian Switzer

Art Director
Esther Mildenberger

Photographers
Fran Thurston, Esther
Mildenberger, Brian Switzer,
students

Country of Origin
UK

Description of Artwork
Catalog for the Architecture &
Interiors Department at the
Royal College of Art, London.

Page Dimensions
150 x 200 mm
$5^7/_8$ x $7^7/_8$ in

Format
Catalog

8th Floor Annual 1998: Infinity-ville

Documenting projects that explore the boundaries of architecture
and virtual space, this catalog reflects these concerns in its design
by the use of gridlines and a strong structural band across each
spread. The bold use of a second color adds real power to the look
of the spreads. The cover, on the other hand, takes its cue from
the title and uses the two colors to create a more abstract and
endless feel.

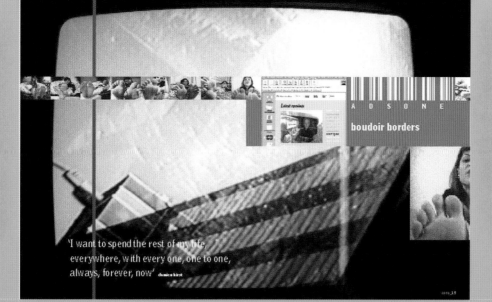

A D S O N E

boudoir borders

'I want to spend the rest of my life, everywhere, with every one, one to one, always, forever, now' damien hirst

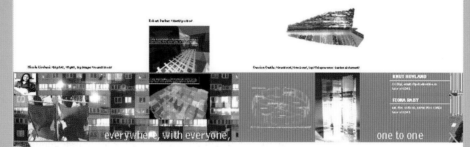

everywhere, with everyone, one to one

KNUT HOVLAND

FIONA RABY

Electronic technologies are connecting our physical spaces and urban environments in unforeseen ways, both within a physical and social realm.

URBAN LOVE TRIANGLE:
Three-way Living

urban love triangle

Christopher Donoghue

boudoir ['buː.dwɑː, -dwɔː] n.
a woman's bedroom or a private sitting room.
The Collins Paperback English Dictionary - 1996

Web cam ['set.kam] n.
1) an electronic camera connected to the World Wide Web
2) a device to relay 'live' images taken from the source camera to the screen of any Internet browser

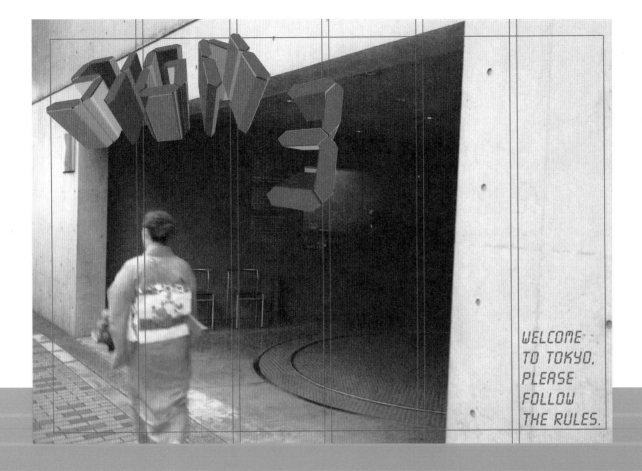

WELCOME
TO TOKYO,
PLEASE
FOLLOW
THE RULES.

Sign 3, Welcome to Tokyo

This promotional book takes the form of a short trip to Tokyo. At first sight
this is an unlikely starting point from which to promote a design company. The
informal nature of the photography creates the illusion of familiarity with the
circumstance. This is set against the device of a superimposed text grid which
refers to the subtitle on the front cover (*left*): Please Follow the Rules. The
pictures themselves also reveal the rules and signage of everyday life in Tokyo.
Taken as a whole, this distinctive publication explores the possibilities of
working imaginatively within a set structure. The highly designed and eccentric
page numbers add a quirky and surreal touch.

Special Production Techniques

The book is constructed in the traditional Japanese manner (with spine to the
right) so that the sequence of pages runs from right to left.

DJS WIE TANAKA VON „FANTASTIC PLASTIC MACHINE" SCHEREN SICH UM KEINE GRENZEN: ENGLISCHE DRUM & BASS-MAXIS WERDEN IN SCHLAGER VON MARY
ROOS UND VERGESSENE HITS VON A-HA GEMIXT. UND ALLES TOBT UND TANZT. OHNE DROGEN UND MIT WENIG ALKOHOL DAUERT JEDE NACHT BIS ZUM
FRÜHEN MORGEN. UM FÜNF UHR NIMMT DIE U-BAHN DEN BETRIEB WIEDER AUF.

HITO, 21, IST SO EINER, DER JEDE NACHT DURCHHÄLT UND DOCH JEDEN MORGEN UM ZEHN UHR IN EINER DER SECOND-HAND-BOUTIQUEN SEINES VATERS
ANTRITT, UM SELTENE LEVIS-JEANS UND ANDERE MODE-RARITÄTEN ZU VERKAUFEN. ER TRÄGT JEANS AUS PAPAS LADEN, EIN HAWAII-HEMD („SEHR GÜN-
STIG") UND NIKE-TURNSCHUHE, VON DENEN ER BEHAUPTET, DASS ES SIE NUR EINEN TAG ZU KAUFEN GAB. DIE GELDSCHEINE, DIE ER AUS DER TASCHE ZIEHT,
SEHEN FRISCH GEDRUCKT AUS, UND OB NUN DIE TOURISTEN AUS GERMANY ODER DOCH AUS JAMAIKA KOMMEN, DAS IST EGAL. WICHTIG IST IHM NUR, WAS
FÜR MARKEN SIE TRAGEN. UND DIE KRISE? HITO STUTZT EINEN KLEINEN AUGENBLICK. „WELCHE KRISE?" FRAGT ER SCHLIESSLICH. OHNE GELD ABER WIRD
SHIBUYA ZU EINEM TRAURIGEN ORT. EINZIG IN YOYOGI PARK, ABSEITS DER LÄRMENDEN EINKAUFSSTRASSEN, FINDET EIN LEBEN STATT, DAS NICHT IN YEN
GEMESSEN WIRD. DRAG QUEENS STELLEN SICH ZUR SCHAU, SCHULMÄDCHEN FÜHREN AKROBATISCHE TÄNZE VOR, UND AMATEURBANDS LÄRMEN UM DIE WETTE.
HIER PULSIERT DER ENERGIESTROM, DER SHIBUYA DURCHZIEHT, EIN WENIG LANGSAMER.

JÖRG BÖCKEM UND CHRISTOPH DALLACH
ZUERST ERSCHIENEN IM SPIEGEL KULTUR EXTRA, HEFT 7/1998

Designer
Antonia Henschel

Art Director
Antonia Henschel

Photographers
Antonia Henschel, Ingmar Kurth

Country of Origin
Germany

Description of Artwork
A 62-page book, third in a
series promoting the German
design company Sign
Kommunikation GmbH.

Page Dimensions
297 X 210 mm
11³/₄ x 8¹/₄ in

Format
Book

DESIGN FOR BUSINESS

Businesses from across the whole commercial spectrum rely on fresh, imaginative design to differentiate themselves from their competitors. The work presented here—calendars, websites, brochures, and catalogs—has been commissioned by companies as diverse as the *International Herald Tribune* and Ultramagic, a Spanish hot-air balloon manufacturer.

SECTION TWO

THE WORLD'S DAILY NEWSPAPER

Designer
Mark Rogerson

Art Director
Mark Rogerson

Photographer
International Herald Tribune
archive

Design Company
Mark Rogerson Associates

Country of Origin
UK

Description of Artwork
Calendar for the *International Herald Tribune* newspaper.

Dimensions
180 x 180 mm
7¹/₈ x 7¹/₈ in

Format
Calendar

FEBRUARY

Herald INTERNATIONAL **Tribune**
PUBLISHED WITH THE NEW YORK TIMES AND THE WASHINGTON POST
THE WORLD'S DAILY NEWSPAPER

Hong Kong, Tuesday, July 1, 1997

In a former Colony, the dawn is red. 1000 protesters defy Beijing as it celebrated its resumption of sovereignty over Hong Kong. Martin Lee vowed to remain 'the voice of Hong Kong,' and called on the new rulers to scrap the Beijing-appointed legislature.

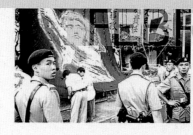

T:01			W:16	
W:02			T:17	
T:03			F:18	
F:04			S:19	
S:05			S:20	
S:06			M:21	
M:07			T:22	
T:08			W:23	
W:09			T:24	
T:10			F:25	
F:11			S:26	
S:12			S:27	
S:13			M:28	
M:14			T:29	
T:15				

Chinese New Year (Dragon)	5
Valentine's Day	14
Paranirvana Day	15

THE WORLD'S DAILY NEWSPAPER

Herald Tribune

Herald International Tribune
THE WORLD'S DAILY NEWSPAPER

European Edition, - Paris, Tuesday, April 16, 1912

London, April 16. The Titanic founders off the banks of
Newfoundland at 10:25 o'clock (New York Time). She sank
2:20 o'clock. Of the 2,358 souls on board the great ship,
only 675, mostly women and children were saved.

OCTOBER

S:01		7:17	
M:02		W:18	
T:03		T:19	
W:04		F:20	
T:05		S:21	
F:06		S:22	
S:07		M:23	
S:08		T:24	
M:09		W:25	
T:10		T:26	
W:11		F:27	
T:12		S:28	
F:13		S:29	
S:14		M:30	
S:15		T:31	
M:16			

Yom Kippur (Day of Atonement)	9
Sukkoth, 1st Day of (Tabernacles)	14
Al-Esra Wa Al Miraj	24
Diwali	26
Hindu New Year	27
EU Summer Time ends	29
Daylight Saving Time ends (CDN, USA)	29
Halloween	31

International Herald Tribune **2000 Calendar**

This strong design for the *International Herald Tribune*, a
traditionally monochrome newspaper, celebrates a century of news
reporting by using text quotes and photographs from the paper's
archives. The layout is based on a simple structure of four blocks:
the large area of yellow; the position of the picture within that color
area; the dark gray area on the other side; and the position of the
second photographic image. The fixed position of the logo and
rolled-up newspaper is orientated for when the calendar is stood
up. The well-considered clarity of the typography in a sans serif
typeface and the clever way its positioning is varied for each month,
makes this apparently simple solution satisfying and fresh for each
month of the year.

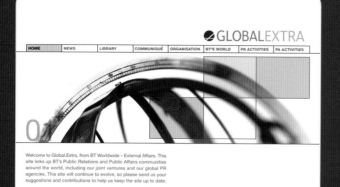

⊘GLOBALEXTRA

| HOME | NEWS | LIBRARY | COMMUNIQUÉ | ORGANISATION | BT'S WORLD | PR ACTIVITIES | PA ACTIVITIES |

01

Welcome to Global.Extra, from BT Worldwide – External Affairs. This
site links up BT's Public Relations and Public Affairs communities
around the world, including our joint ventures and our global PR
agencies. This site will continue to evolve, so please send us your
suggestions and contributions to help us keep the site up to date.

⊘LIBRARY

| HOME | NEWS | LIBRARY | COMMUNIQUÉ | ORGANISATION | BT'S WORLD | PR ACTIVITIES | PA ACTIVITIES |

03

USEFUL SITES
BT INTERNATIONAL LIBRARY COLLECTION
BT PICTURE LIBRARY
HOW TO USE THE LIBRARY
BROWSE THE LIBRARY, SELECT & ORDER PHOTOGRAPHS

BT FACTS
BT & THE ENVIRONMENT
COMMUNICATIONS, RESEARCH & ANALYSIS
PLACES TO VISIT
A SHORT HISTORY OF BT'S WORLD

⊘PR ACTIVITIES

| HOME | NEWS | LIBRARY | COMMUNIQUÉ | ORGANISATION | BT'S WORLD | PR ACTIVITIES | PA ACTIVITIES |

07

PR FACTFILE CALENDAR OF EVENTS

⊘NEWS

| HOME | NEWS | LIBRARY | COMMUNIQUÉ | ORGANISATION | BT'S WORLD | PR ACTIVITIES | PA ACTIVITIES |

02

BT CORPORATE NEWS RELEASES MEDIA MONITORING
BT COMMUNICATION STORE FEATURE ARTICLES
BT LABORATORIES

⊘COMMUNIQUÉ

| HOME | NEWS | LIBRARY | COMMUNIQUÉ | ORGANISATION | BT'S WORLD | PR ACTIVITIES | PA ACTIVITIES |

04

HEADLINES

⊘PA ACTIVITIES

| HOME | NEWS | LIBRARY | COMMUNIQUÉ | ORGANISATION | BT'S WORLD | PR ACTIVITIES | PA ACTIVITIES |

08

WHO ARE WE VISIT OUR EXTERNAL WEBSITE – CHOICE.COM
WHAT WE DO LIBERALISATION MILESTONES
ROLLING ISSUE REPORT YESTERDAY'S TOMMOROW – THE VIDEO

BT Global Extra Intranet Site

Simply using the logo and web-page title in a set position above the navigation bar, over similarly treated abstract imagery, gives this site a clean, stylish, and consistent appearance. The strong typographic framework provides a corporate look to a site which contains much diverse information. The regularity of the design also makes it easy for users to familiarize themselves with the site layout and enables them to find relevant information quickly.

Designer
Mark Rogerson

Art Directors
Mark Rogerson,
Jonathan Brade

Photographer
Jonathan Brade

Design Company
Mark Rogerson Associates

Country of Origin
UK

Description of Artwork
Intranet site for British
Telecom Worldwide External
Affairs used by BT's
advertising agencies and
PR companies to source BT
information including the
latest news, logos, corporate
guidelines, and stock
photography.

Dimensions
Varies to screen size

Format
Website

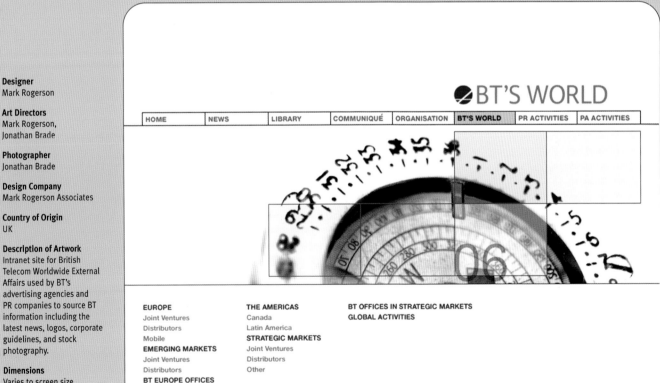

Designer
Martin Brown

Art Directors
Jim Sutherland, Pierre Vermeir

Photographer
Phil Starling

Design Company
HGV Design

Country of Origin
UK

Description of Artwork
Spiral-bound direct mail
brochure for a rail-based
parcel-courier company.

Dimensions (Main Page)
297 x 210 mm
11³/₄ x 8¹/₄ in

Format
Brochure

Esprit Europe Brochure

This imaginative brochure combines high-quality photography, railway-inspired
graphics, and an ingenious use of spiral binding to produce a very effective promotional
publication that works on many different levels. The photography evokes the romance
and speed of the train, while the text is presented in ways that directly connect with the
graphic devices employed at railroad stations. For example, the clever use of spiral
binding and alternate thin 'flip' pages mimics the rollerdeck-style of announcement
board used in many station terminuses.

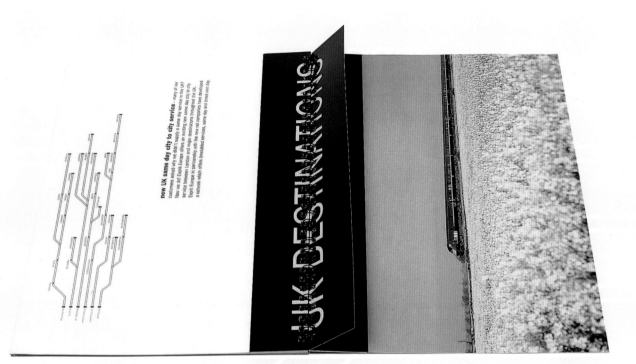

Visual references to the railroad are used to enliven the text.
Here, the information is presented in the form of a railroad
network diagram.

The thin 'flip' page not only allows two different messages to
be presented on the same spread, but also involves the reader
in flipping the page to find out what is hidden beneath.

Immortality Poster

Created as part of a promotion for paper, the designer has chosen images 'to depict the immortal quality' of the medium. The juxtaposition of images and text draws the reader in and creates a beguiling atmosphere; while the treatment of the typography (different typefaces used in a variety of colors, sizes, and states of legibility) adds texture to the overall composition.

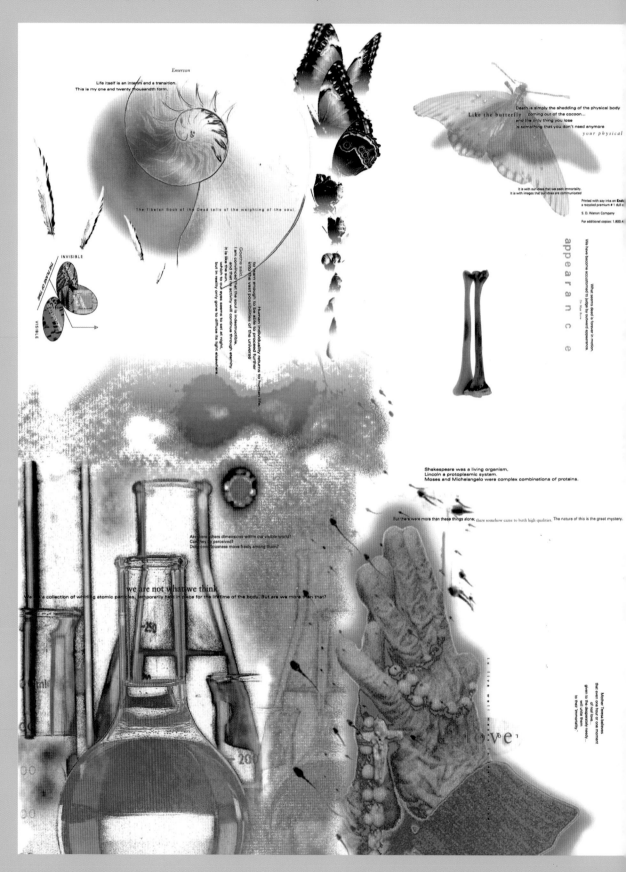

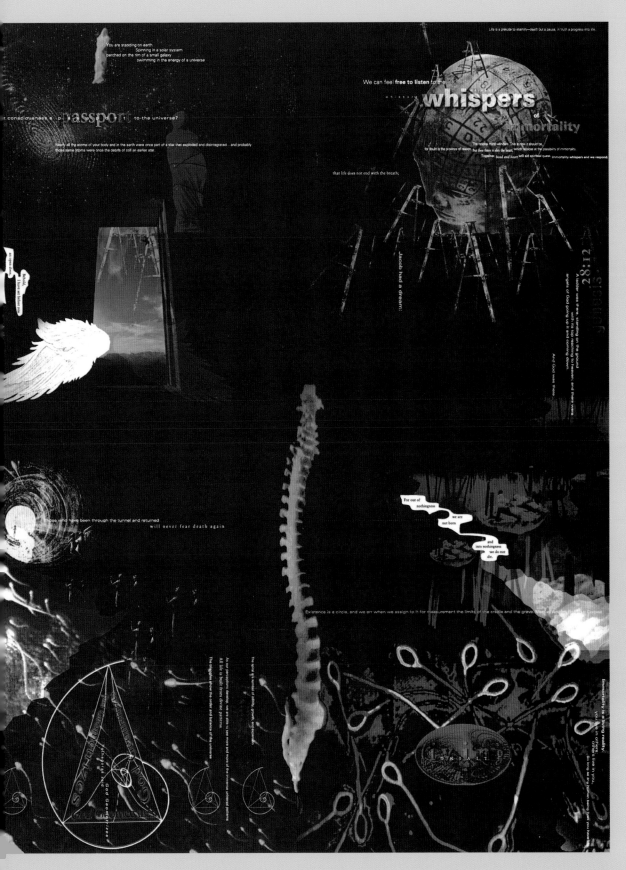

Designer
Rafael Esquer

Art Director
Rafael Esquer

Instructor
Steve Madden

Art College
Art Center College of Design

Country of Origin
USA

Description of Artwork
Double-sided concept poster designed to promote the use of paper.

Dimensions
550 x 710 mm
21³/₄ x 28³/₈ in

Format
Poster

Ultramagic

Ultra
magic

Globos
Balloons
熱気球
Heißluftballone
Montgolfières
Globus
Montgolfiera
Balónu
Ballonger
Kuumailmapallot
Balões
Ballons
АЭРОСТАТЫ

Ultramagic

The simple line-and-flat-color cover (*opposite*) gives little away about what to expect inside this multilingual catalog. Once inside, images and text seem to float across the page, creating a sense of space and freedom. The catalog has been used to promote the bespoke nature of balloon construction and to encourage the reader to start imagining their own design by the inclusion of color swatches down the side of one spread (*bottom, right*).

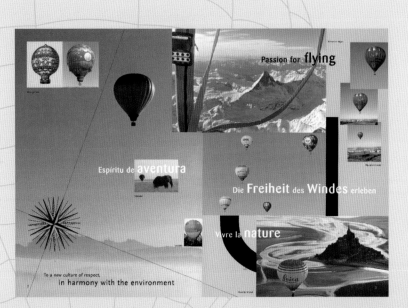

Left: the inclusion of historical imagery sets up a contrast that emphasizes the modern nature of ballooning.

Below: the images of a balloon under construction illustrate the high degree of care and attention to detail offered by the company.

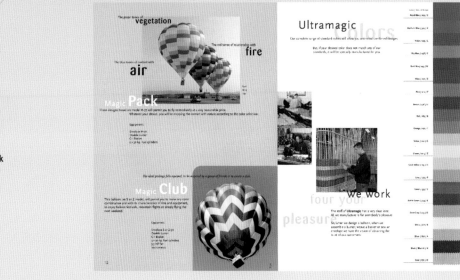

Designer
Lluis Jubert

Art Director
Ramon Enrich

Illustrations
Ultramagic Archive

Photographers
Roger Velazquez and various

Design Company
Espai Grafic

Country of Origin
Spain

Description of Artwork
Promotional catalog for a balloon factory near Barcelona.

Page Dimensions
210 x 295 mm
8¹/₄ x 11⁵/₈ in

Format
Catalog

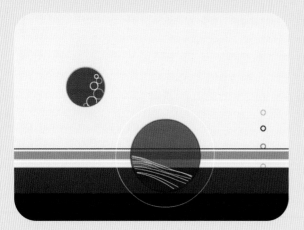

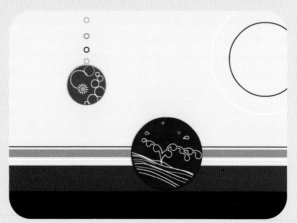

100% original

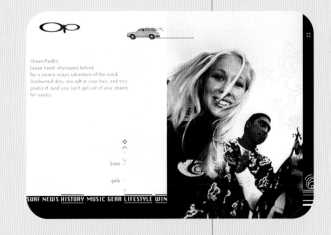

Ocean Pacific

The opening animated sequence (*opposite*) establishes a visual style within which different types of information can be presented while maintaining the overall identity of the company Ocean Pacific. This complex site combines text, still images, and short animations in a highly appealing and accessible format.

Opposite: the motif of rising bubbles, first seen in the opening sequence, is subsequently used as a device to access information. When the cursor is placed over the word LIFESTYLE, bubbles rise from behind it to reveal two options: 'boys' or 'girls.'

Right: two main graphic devices are employed to help separate different types of information—the division of the screen 75:25 (*top*), and a black rim along the bottom and right-hand side (*center and bottom*).

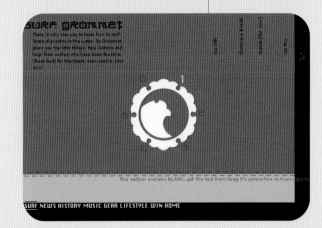

Designers
Mark Allen, Adrianne De Loia,
Alejandra Jarabo, Chris Martinez

Art Director
Adrianne De Loia

Illustrators
Adrianne De Loia, Alejandra
Jarabo

Photographer
Adrianne De Loia

Design Company
Kick Media

Country of Origin
USA

Description of Artwork
Website for Ocean Pacific,
showcasing clothing, lifestyles,
games, surf pro, and the surf
dance.

Dimensions
640 x 480 pixels

Format
Website

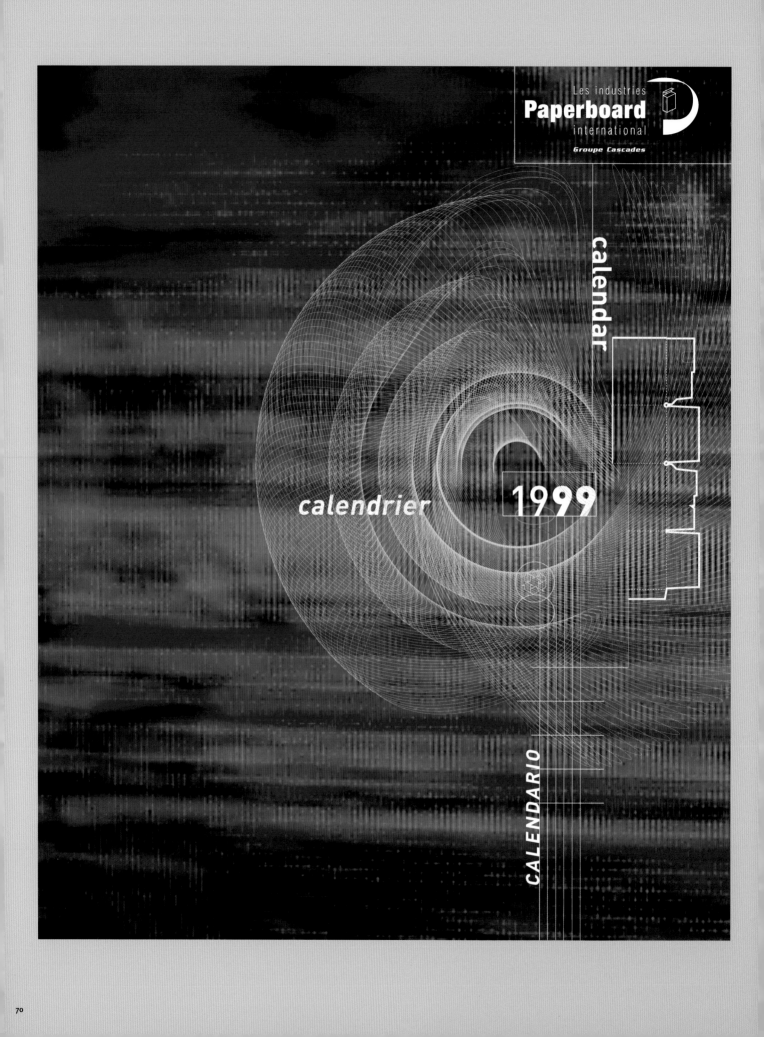

***Les Industries Paperboard International* Calendar 1999**

The brief was to promote the equipment used in the production of paperboard. The designers have taken images which are in themselves descriptive rather than inspirational and have used the design to suggest the advanced nature of the technology. The use of geometric patterns and a consistent style of type and color panels draws together the different qualities of the photographs, presenting them in a fresh and dynamic way.

Designer
Catherine Petter

Creative Directors
Daniel Fortin, George Fok

Art Director
Catherine Petter

Illustrator
Catherine Petter

Photographer
Jean-François Gratton

Design Company
Époxy

Country of Origin
Canada

Description of Artwork
Trilingual calendar designed to showcase the high-tech equipment of Les Industries Paperboard International.

Dimensions
406 x 507 mm
16 x 20 in

Format
Calendar

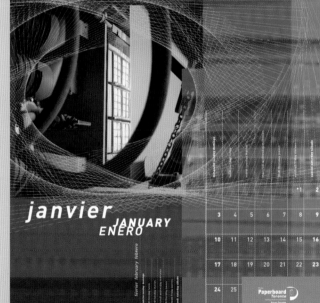

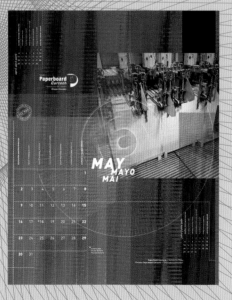

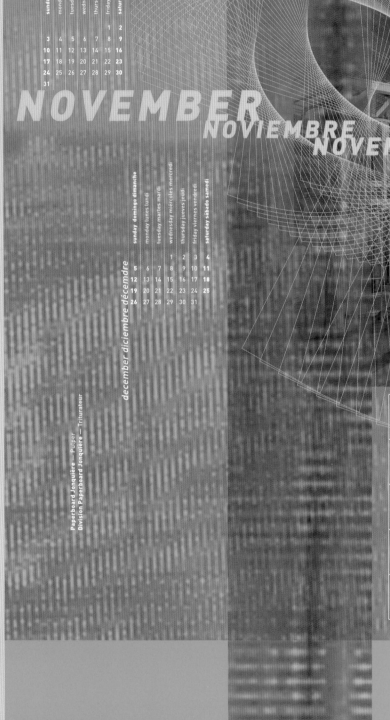

sunday domingo dimanche	monday lunes lundi	tuesday martes mardi	wednesday miércoles mercredi	thursday jueves jeudi	friday viernes vendredi	saturday sábado samedi
					1	2
3	4	5	6	7	8	9
10	11	12	13	14	15	16
17	18	19	20	21	22	23
24	25	26	27	28	29	30
31						

NOVEMBER
NOVIEMBRE
NOVEMBRE

december diciembre décembre

sunday domingo dimanche	monday lunes lundi	tuesday martes mardi	wednesday miércoles mercredi	thursday jueves jeudi	friday viernes vendredi	saturday sábado samedi
			1	2	3	4
5	6	7	8	9	10	11
12	13	14	15	16	17	18
19	20	21	22	23	24	25
26	27	28	29	30	31	

Paperboard Jonquière — Pulper
Division Paperboard Jonquière — Triturateur

Division
Paperboard
Jonquière
Paperboard Industries Corporation
Groupe Cascades

sunday domingo dimanche	monday lunes lundi	tuesday martes mardi	wednesday miércoles mercredi	thursday jueves jeudi	friday viernes vendredi	saturday sábado samedi
	1	2	3	4	5	6
7	8	9	10	*11	12	13
14	15	16	17	18	19	20
21	22	23	24	25	26	27
28	29	30				

ISO 9002
ENREGISTRÉ · REGISTERED

* Remembrance Day
Jour du souvenir
Día del recuerdo

diciembre
DÉCEMBRE
DECEMBER

noviembre novembre november

domingo dimanche sunday	lunes lundi monday	martes mardi tuesday	miércoles mercredi wednesday	jueves jeudi thursday	viernes vendredi friday	sábado samedi saturday
	1	2	3	4	5	6
7	8	9	10	11	12	13
14	15	16	17	18	19	20
21	22	23	24	25	26	27
28	29	30				

domingo dimanche sunday	lunes lundi monday	martes mardi tuesday	miércoles mercredi wednesday	jueves jeudi thursday	viernes vendredi friday	sábado samedi saturday
			1	2	3	4
5	6	7	8	9	10	11
12	13	14	15	16	17	18
19	20	21	22	23	24	25
26	27	28	29	30	31	

* Navidad / Noël / Christmas Day

Division Paperboard Jonquière — Traitement des eaux usées
Paperboard Jonquière — Waste Water Treatment

ENREGISTRÉ • ISO 9002 • REGISTERED

Division
Paperboard
Jonquière
Paperboard Industries Corporation
Groupe Cascades

DESIGN FOR EDUCATION
AND THE ARTS

The pieces shown in this final section are centered around the worlds
of education and the arts. Cultural websites, university-faculty brochures, CD
packaging, invitations to art exhibitions—a wide range of design projects,
demonstrating an equally wide range of approaches and solutions.

SECTION THREE

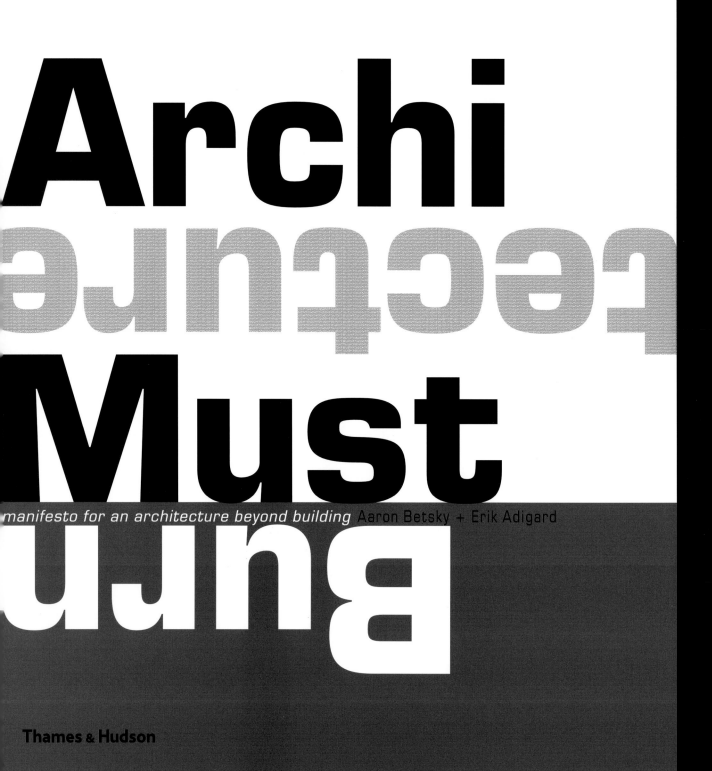

Archi
tecture
Must
Burn

manifesto for an architecture beyond building Aaron Betsky + Erik Adigard

Thames & Hudson

Designers
Erik Adigard, Patricia McShane

Art Director
Erik Adigard

Illustrator
Erik Adigard

Design Company
M.A.D.

Country of Origin
USA

Description of Artwork
144-page book that examines possible strategies for living in an electronic age. Text by Aaron Betsky and Erik Adigard.

Page Dimensions
229 x 279 mm
9 x 11 in

Format
Book

Architecture Must Burn

Bold type and simple flat color give the provocative title (*left*) a powerful presence, while the device of turning parts of the title upside-down suggests the subversive and surprising nature of the book's content. The design inside (*see next page*) contrasts the layered styling of the typography with enigmatic imagery—sometimes bold, sometimes complex and abstract—underlying the atmosphere of architectural chaos and 'sprawl' which is the subject of the text.

The central generator of sprawl is the road. Over a quarter of our urbanized areas are covered with collections of empty arteries that represent no more and no less than potential: places always prepared for movement but in themselves no-place. The road always leads somewhere else, carving out a void and eviscerating everything around it. These days we try to contain **highways** with walls, embankments and regulations, turning them into surreally invisible slashes across our land. As soon as the road slows down, it re-enters the fabric of sprawl, eating out more space for itself with intersections and the I-, U- and L-shaped constructions that allow parking in front of stores and businesses. The road, in other words, seeps out to flatten everything around it to make room for the highest value in our society: not freedom or money, but access.

The road is thus the human-made equivalent of the river that shaped so much of the land we inhabit. It creates connections and barriers, cuts into the land to create breaks in the undulating terrain and generates activity on its banks. The road and the river are metaphors of movement and change, but also very real places where one can float, isolated from the city's grids and laws of nature, creating a freer culture: the world of riverboat gamblers, truckers and the Snowbirding tribes in their RVs.

Up above, skyways course around the globe. They are meta-roads that leave far behind the railroad and shipping lanes that once symbolized the freedom and vast expanses to which the road could only aspire. Their physical manifestation are airport runways. They are small segments of road that show us only the beginning and the end of a journey that is completely divorced from geography. They eat up huge amounts of space, making us realize how great the emptiness caused by the road causes really is. Even inside the adjacent airports, empty transience pervades and eats out buildings that are places for limbo; jet-lag carries the road's vacant nature into our own bodies.

We have long romanticized the road. It is the way to freedom, the act of moving beyond Eden into an untamed nature. The first humans were nomads, and in some ways we memorialized their peregrinations in the earliest roads (such as the Road of the Kings that traced the Fertile Crescent). The road is also the way to power, the path of conquest that, at crossings, at the bottom of mountains or at springs, turns into what the Romans called the *cardo*, engendering the very urban civilization of which we are so proud. Their needs framed an entire empire by proliferating crossroads that connected regions, blocks, houses and rooms, all making abstract geometry real.

In the United States, the road embodies our manifest destiny. It is the line of escape that accommodates ever more immigrants in search of a New Eden. That perfect place is always located somewhere that is not now and here. It is just beyond the place where the perspective edges of the road out of town converge into infinity. It is a place of economic and physical escape, along which we can move into the future and a better life by gobbling up rocks and trees on the way and turning them into usable resources.

In our current culture the road is in many ways more important than the town. If the road once disappeared into a metropolitan maze as soon as it entered through the city gates, today it has become the city walls, in the form of beltways that encircle most of our metropolises. In many cities, there is no longer a central urban core, only the "strip": the elongation of commercial and sometimes civic development along paths leading somewhere else. "Houston is a city running away from itself, always further west," says architect and critic Lars Lerup of his own town. On a smaller scale, neighborhoods have disappeared into planned enclaves or gridded developments that expose the geometry and sheer presence of the road as the most significant aspect of the landscape. We travel from entry to entry, or along a rhythm of intersections with a monotonous predictability. At a smaller scale still, roads turn into the driveways that dominate our houses' front façades. We try to curb the creation of more roads, blaming not their presence but the vehicles that relentlessly use them for the corrosion of our landscape. We think that by limiting the presence of cars, hiding them behind buildings and pooling them in parking garages at the periphery of pedestrian zones, we can defeat the road. But the road is more essential and can never be marginalized. It just becomes the route of the light-rail system, the void of the shopping street, the outdoor mall that takes over the city. To many, the road is therefore the great destroyer. It replaces certainty and place with movement and space. Yet it is also the great fulfillment of modern culture's dream, our manifest destiny to keep moving as the new nomads who have freed themselves from the constraints of place and history. It is the ultimate modernist space, where movement, speed and change disintegrate all fixed forms into abstraction. The road is a collage generator that mixes and matches the real world into a continually changing composition, leaving us to be the deracinated interpreters who make sense of it all. The artery of sprawl might unleash us to the wonder of discovery, even as it seems to destroy all that we hold dear.

imagineering

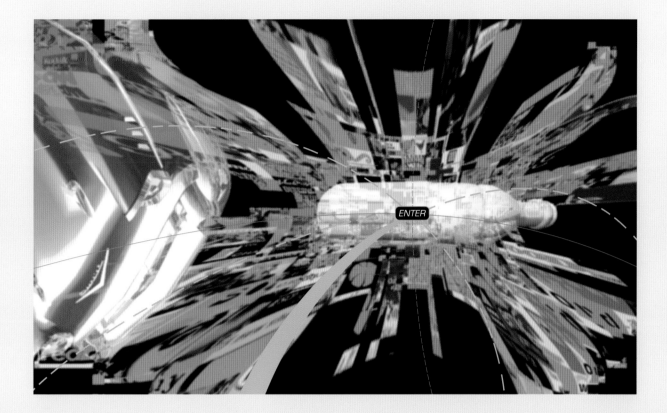

ENTER

What makes sprawl work are its magnets of meaning: objects and spaces that provide focus in a disparate world. They can be as big as a football stadium or as small as a pair of blue jeans. The "attractors" catch our attention in the field through which we move every day. They also capture our investments of time and money. Their scale, form and composition are both molded by sprawl and give it definition. Attractors make some sort of sense in the realm of sprawl.

Attractors are what stabilize emergent, entropic systems. Since the advent of chaos theory in science, experts in disciplines as far apart as biology and astrophysics have become interested in how smooth, undifferentiated space begins to differentiate itself into a self-forming, or "epigenetic," landscape around one or more centers of attraction. Systems gyrate in wild loops among these attractors, until they fall into repetitive rhythms and finally freeze into place. It is in the tenuous state between chaos and order that the greatest energy exists in a system. In human terms, such a state might be called creativity, which can occur at times of crisis. Sprawl is also such a state. It used to be that cities coalesced around natural features: the places where it was easy to cross a river, a natural harbor, a spring or a high, defensible point. Humans civilized these features with structures of resistance (castles), the domiciles of those who controlled the feature (traders, warlords) and with expressions of wealth extracted from the surrounding countryside and transformed into symbolic artifacts (cathedrals, mosques).

Over time, cities became their own landscapes, thrusting up skyscraper ridges and forests of housing blocks. Cities assumed their own topographies; nowadays we navigate through them by landmarks, at major intersections or in the middle of large clearings. The institutions of culture and finance, the monuments to our past achievements or the monuments where movement becomes visible – railroad stations or freeway overpasses – are today's equivalent to the river crossing, Mount Fuji or New York harbor.

As capital has been disseminated throughout our landscape, new landmarks have appeared. Some sprout up like little pieces of the city from which they have fled. Freeway intersections are marked by shopping malls, office compounds and dense housing arrangements. But a strange inversion takes place: the point of crossing does not lead to a landmark; instead it becomes the empty core of one. Similarly, large buildings no longer focus on a plaza or square, but on an often unpassable barrier of movement.

The largest structures one finds in such places are even stranger. Like castles, they have a closed appearance with only a few entrances; they are surrounded by an easily defensible space; their riches are inside, where they are laid out in a labyrinth whose ultimate focal points are places of entertainment and dining. These monoliths are, of course, shopping malls. Bland on the outside, they look out over seas of parking that let people get as close to the keep as possible without having to contend with weather or undesirable sorts. Inside, the visitor meanders through our culture's treasury on route to the food court or multiplex.

Even stranger are the largest attractors that rise out of the world of sprawl. There are three kinds: back-office blocks, places of transportation or trans-shipping, and stadia and convention centers. The first kind crop up like Edge City crystals, rising up around road intersections, sheered off into blocks of air-conditioned ice that sit in the middle of nowhere. Inside, thousands of phone operators or data clerks toil away in oceans of anonymity. These blocks could be anywhere. They are abstract fragments of a world made real.

The second type of these attractors are the airports, truck stops and regional warehouses that move people or material goods. Despite some attempts to make airports into places of beauty, the effects of structural exhilaration and vast scale are fleeting as the planes they house. On the outside, airports are spiders' webs of terminals, parking garages, service spaces, ramps and gates that spread out through seas of tarmac. They have no recognizable form or relationship to human experience.

Stadia and convention centers, the third great attractors, do. These large blobs proudly display the mammoth structure it takes to accommodate tens of thousands. Each city has its own signature form, but they are all designed by a handful of firms whose primary concern is to maximize space usage in a manner that differentiates among pay scales and uses. These structures are about booth rentals and skyboxes, not about the communal experience of a place. After a period of quiet, they are again appearing in traditional cities, and although they might cloak themselves in a thin veneer of local color, they now bring sprawling scale into spectatorship, transfering the environment and the factory aesthetic to the heart of the urban experience.

The strangest aspect of such attractors is that they have taken a world focused on places of power and replaced them with realms of leisure. The promenades through shopping arcades and the gathering around conventionalized violence in the stadium stand in for the great palaces and factories that used be our daily destinations. Monuments of movement have replaced points of destination. Even the back-office space has become a holding pen for activities that take place not in this world but in cyberspace, tethered only to an external reality by phone cords and the rituals of selling. There is no there there, anywhere, only a suggestion of somewhere else around which we circulate.

These attractors attract investment, are the largest things on the landscape and are our navigational focal points. They are, however, profoundly empty. They are warehouses devoid of meaning: No sense or product is made there. We can find no certainty there, no place to gather and define ourselves as a culture. These attractors are mute enigmas that absorb energy and money and give nothing back. The empty football field symbolizes their moment of tr

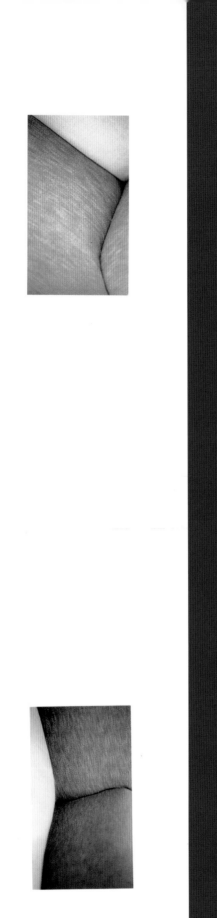

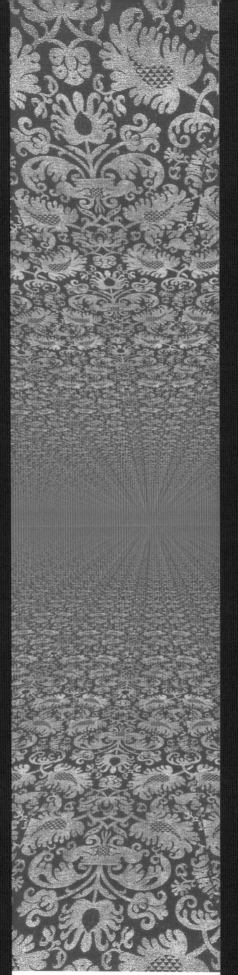

Simone Cobbold

10 Butts Road, Stanford-Le-Hope, Essex SS17 OJH

(01375) 404 287

"Harry" 1997

Tracey Vane

2 May Court, Little Thurrock, Essex RM17 6UB

(01375) 384 042

"Damask!" 1998

Beverley Holgate

Coggeshall Hall, Coggeshall Road, Kelvedon,
Colchester, CO5 9PH

(01376) 570 394

"Untitled" 1998

Stretched

The layout of each double-page spread in this college catalog has been individually designed to present the featured artist's work in the best light. The use of the 'check book' format, with its subliminal allusion to the relationship between art and commerce, is a striking way to display the wide range of work on show.

Second from left: with the gutter as a horizon, the layout for Tracey Vane's *Damask!* utilizes the long format brilliantly to create the illusion of a limitless expanse.

Third from left: by leaving as much blank space as possible between the images, the designer has set up an ambiguous, questioning relationship between the two pages of Beverley Holgate's *Untitled* giving a delicate feel to this spread.

Designer
Gavin Ambrose

Art Director
Gavin Ambrose

Photographer
Arnold Borgerth

Design Company
Mono

Country of Origin
UK

Description of Artwork
48-page brochure for the 1998 graduation exhibition of the BA Textiles degree course at Goldsmiths' College, London.

Page Dimensions
210 x 85 mm
8¹/₄ x 3³/₄ in

Format
Brochure

Elisabeth Stoschka
45 Cranfield Road, Brockley, London SE4 1TN
(0181) 692 4258
'Touch Me' Wax, plas, needle & wire, 1998.

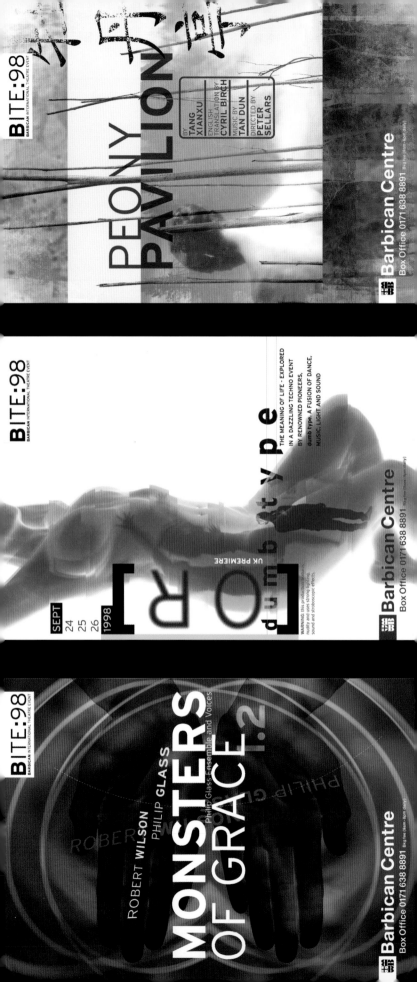

Barbican Centre BITE:98 and BITE:99

The diversity of the events within the 1998 season of this international theater festival is reflected in the promotional leaflets (*above*). One of the few constant elements on them is the festival logotype and its position. This is enough to indicate that all three events belong under the BITE umbrella. For the 1999 season, the logotype was further developed to become the central point of the dramatic and surreal imagery used on the cover of the festival brochure (*left*). This fiery treatment has been carried through to the inside (*below*) where it is contrasted, very effectively, with the clean, asymmetric typography.

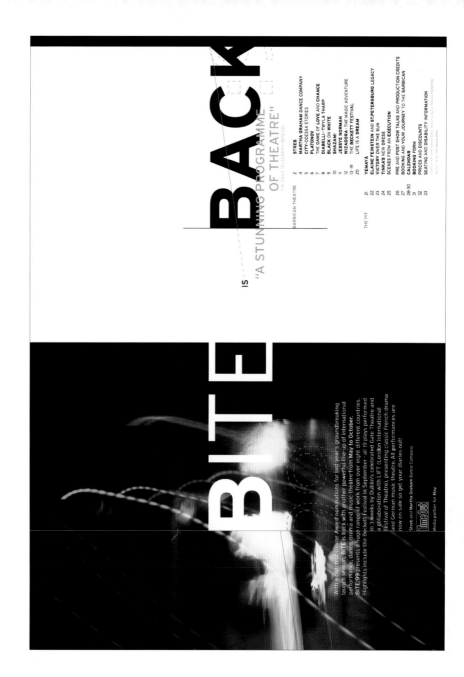

BACK
IS — "A STUNNING PROGRAMME
OF THEATRE"
THE DAILY TELEGRAPH (BITE:98)

BITE
PIT

With that much Olivier Award nominations for last year's groundbreaking launch season, BITE is back with another powerful line-up of international performance, dance, drama and music-theatre from **May to October**.

BITE:99 presents a huge range of work from over eight different countries. Highlights include the Beckett Festival in September all 19 plays performed in 3 weeks by Dublin's celebrated Gate Theatre and a collaboration with LIFT (London International Festival of Theatre), presenting classic French drama and German music theatre. All performances are now on sale so get your diaries out!

Streb and Martha Graham Dance Company

Time Out
Media partner for **May**

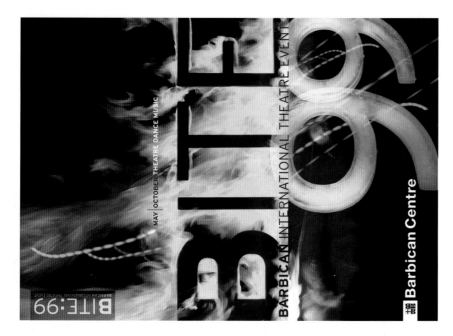

MAY | OCTOBER THEATRE DANCE MUSIC

BITE:99
BARBICAN INTERNATIONAL THEATRE EVENT

■■ Barbican Centre

Designers
Why Not Associates

Design Company
Why Not Associates

Photographers
Photodisc (BITE:98 Monsters
of Grace and Peony Pavilion),
E. Valette and Rocco Redondo
(BITE:98 OR), Rocco Redondo
(BITE:99 Brochure)

Country of Origin
UK

Description of Artwork
Promotional leaflets (*opposite page*) and brochure (*above and right*) for the Barbican Centre BITE Festival, 1998 and 1999.

Dimensions
148 x 210 mm
5 $^{7}/_{8}$ x 8 $^{1}/_{4}$ in

Formats
Leaflets and brochure

Graphic Identity for Jazzmonitor

Enigmatic photography, bold typography, the controlled use of flat color, and a careful choice of color palette all combine here to produce a very effective and strong visual identity. This solution is flexible and distinctive enough to work at different scales, ranging from a small business card to the size of a poster (*left*). The slightly abstract hard-edged style of imagery adds to the urban mystique of this club event.

Designer
Peter Bruhn

Art Director
Peter Bruhn

Photographer
Peter Bruhn

Design Company
Fountain-Bruhn

Country of Origin
Sweden

Description of Artwork
Poster (*left*) and flier (*following spread*), as part of a package including letterhead, logo, business card, and labels, for the ambient club event Jazzmonitor.

Dimensions
Poster: 500 x 500 mm
19^3/$_4$ x 19^3/$_4$ in
Flier: 286 x 95 mm
11^1/$_4$ x 3^3/$_4$ in

Formats
Poster and flier

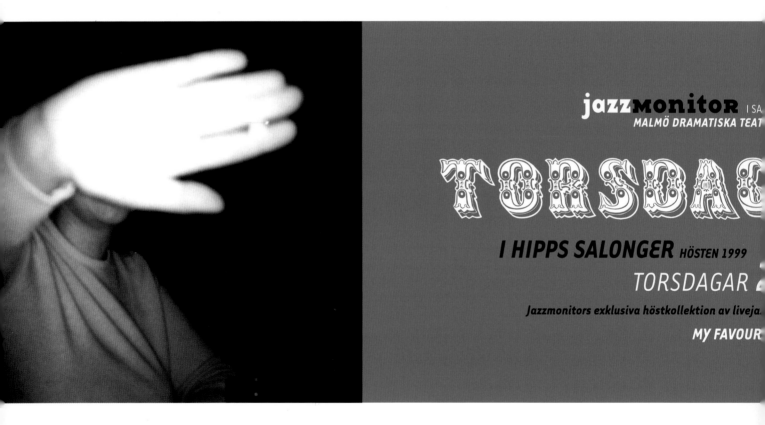

This dramatic image gives the impression
that this club event is not for the uninitiated.

ED
K JAZZFORBUND OCH KWAI TSAN
PRESENTERAR

00 – 24.00

benhavn och Malmö

GS – Jazz på CD och vinyl

Left & below: the consistent use of carefully chosen colors and the repetition of the same photograph on both the poster (*see previous spread*) and flier (*below*) set up a series of visual connections that serve to strengthen the Jazzmonitor identity.

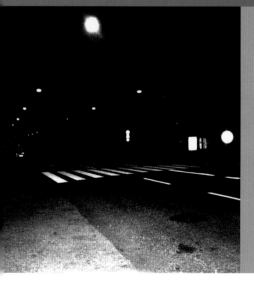

TEATERSALONGEN, HIPP KALENDEGATAN 12, MALMÖ.

jazzmonitor PRESENTERAR

Renegade Way

Steve Coleman (AS) **Gary Thomas** (TS)

The Rick (DR) **Ravi Coltrane** (TS) TORSDAGEN DEN
Greg Osby (AS) Anthony Tidd (B) *28 OKTOBER*

INSLÄPP 20.00, BILJETTER 140 SKR

Förköp Hipps biljettkassa Kalendegatan 2.

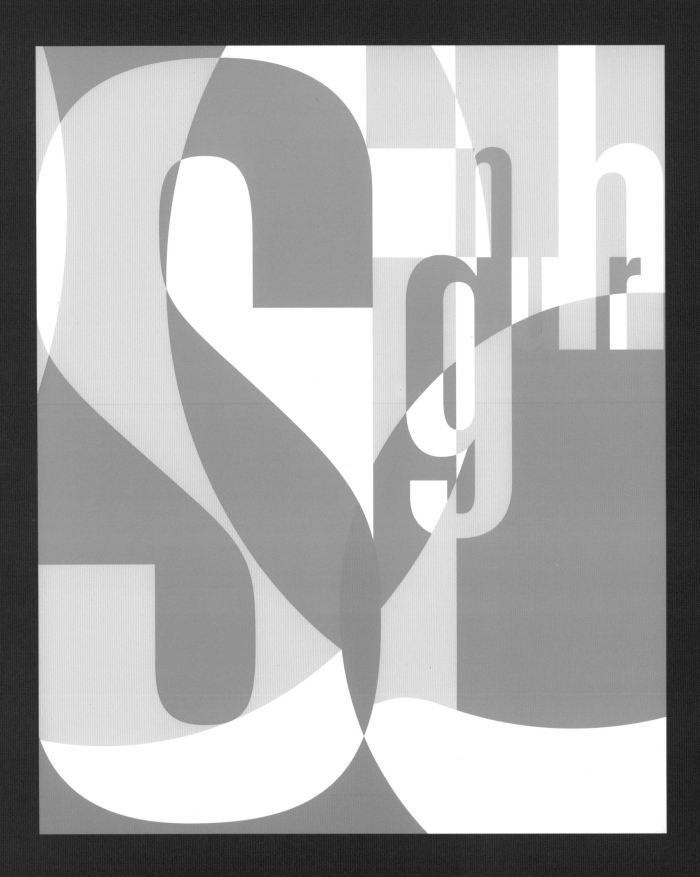

Singuhr Klangkunst

The abstract concept of a sound-art gallery is, by its very nature,
hard to visualize. Faced with this challenge, the designers chose
simplicity and a bold abstract approach to create an intriguing visual
analogy for the events at the gallery. The cover typography (*opposite*)
makes clever use of three colors to suggest overlapping circular
ripples of spreading sound. Inside, this mental image extends to the
display of photographic imagery (*below*). On the typographic pages
(*shown on the following spread*), the blocks of text have been
sculpted to suggest the nature of the aural experience, with curved
margins and text blocks 'bouncing' off each other like echoes. The
use of monochrome adds a starkness to each composition.

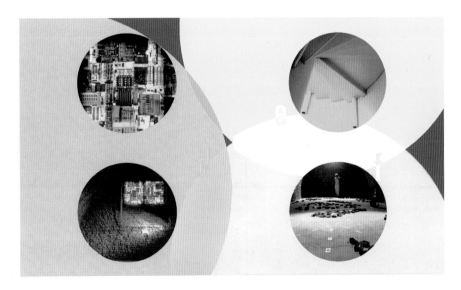

Designers
Cyan

Photographer
Roland Maerz

Design Company
Cyan

Country of Origin
Germany

Description of Artwork
120-page catalog
documenting the activities
of the sound-art gallery
Singuhr from 1996–98.

Page Dimensions
200 x 233 mm
$7^7/_8$ x $9^1/_8$ in

Format
Catalog

ben von Jacobis Glocken urteilte dieser, daß die verwendete Legierung nicht für Spielglocken geeignet sei. Gleichzeitig bot er ein neues

Carillon an. Im August 1716 starb Weiß und im März 1717 wurde der Niederländer Arnoldus Carsseboom als sein Nachfolger eingestellt, allerdings gab es kein vollständiges Instrument mehr. Zwei Jahre nach der enttäuschenden Einweihung des Carillons schrieb König Friedrich Wilhelm I. u. a. an den Kirchenrat der Parochialkirche: Vornach ihr Euch also gehorsamst zu achten, ... und zwar bey Verlust der von Uns Euch hierunter zugewendeten Gnade zu sehen habt, daß binnen Jahresfrist ein anderes tüchtiges und vollkommenes Glocken-Spiel aus Holland angeschaffet und an der jetzigen Stelle wieder aufgesetzet werde.¹ Daraufhin wandte sich das Presbyterium im April 1717 an den Glockengießer de Grave mit der Bitte um einen neuen Glockenchor. Bereits am 4. Oktober 1717 wurde das neue Carillon, versehen mit einem hervorragenden Gutachten, auf dem Schiffsweg von Amsterdam nach Berlin geschickt. Carillonneur Carsseboom übernahm die sofortige Installation und schon im November 1717 erklang das zweite Berliner Carillon (Abb. 6). Es bestand aus den 35 Glocken von de Grave mit einem Gesamtgewicht von 7,3 Tonnen. Die Herkunft der zwei kleinsten Glocken (36. und 37.) ist nicht nachweisbar. Wahrscheinlich sind sie erst 1797 oder 1838 bei der Generalüberholungen hinzugefügt worden. Auch der Stockspieltisch besaß nach einem 1764 erschienenen Bericht von Johann Samuel Halle nur 35 Tastenstöcke (22 sogenannte weiße und 13 sogenannte schwarze). Erst ein weiterer Bericht aus dem Jahre 1846 spricht von 37 Glocken. Die Aufhängung der Glocken in der Glockenkammer war symmetrisch (Abb. 7), die fünf größten Glocken hingen in der Mitte und um diese ordneten sich die restlichen Glocken in Reihen im West-, Nord- und Südfenster des Turms. Der Stockspieltisch war in einer hölzernen Spielkabine auf dem Boden des Glockengeschosses untergebracht und über ein mechanisches System mit den Glockenklöppeln verbunden. Er wurde per Hand gespielt. Eine automatische Vorrichtung verkoppelte das Carillon über eine Eisenwalze mit der Turmuhr (Abb. 2). Bei dem Uhrglockenspiel erfolgte der Glockenanschlag über zusätzlich montierte Glockenhämmer auf den Glockenaußenseiten, die von der Automatik in Gang gesetzt wurden. Die Walze der Automatik besaß für den Melodienwechsel auswechselbare Metallstifte, deren Länge und Anordnung Tonhöhe und Anschlagzeitpunkt bestimmten. Alle siebeneinhalb Minuten erklang ein Zeitsignal, viertelstündlich ein kurzer und halbstündlich ein längerer Choral, immer mit Vor- und Nachspiel. Die Melodien, z.B. kleine Fugen, verzierte Psalmenmelodien und Choräle, wurden 14-15 mal im Jahr gewechselt: zu Advent, Weihnachten, Neujahr, zur Passionszeit, zu Ostern, Himmelfahrt, Pfingsten, zum Reformationsfest und zu den Monatsanfängen von Februar, Juli, August, September und Oktober. Auf dem Carillon der Parochialkirche gab es von Beginn an eine rege Konzerttätigkeit. Siebzehn Carilloneure waren hier tätig. Sie hatten die Aufgabe, die Walze des Glockenspiels mit den entsprechenden Melodien zu bestiften und Carillon-Konzerte zu spielen. Gespielt wurde auf dem Carillon an Festtagen, bei Hochzeiten und Begräbnissen. Zu den Geburtstagen der Herrscherhauses erklang noch bis 1918 stets ein Sonderkonzert zur Mittagszeit. Ebenso boten Kriegssiege und hohe Staatsbesuche Anlaß zu Sonderkonzerten.

¹ ibid. S.69

Regelmäßige Konzerte erklangen zwischen 1717 und 1782 an drei Tagen in der Woche (Sonntag, Mittwoch und Freitag), im Sommer von 5-6 Uhr nachmittags, ansonsten von 11-12 Uhr morgens. Von 1782-1839 wurde das Carillon zweimal wöchentlich (Sonntag, Mittwoch) ca. eine Stunde gespielt. Zwischen 1839 und 1848 war dem Carillonneur Ludwig Thiele nur ein Konzert wöchentlich erlaubt, Sonntags von 12-13 Uhr. Sein Nachfolger durfte nur noch halbstündige Konzerte einmal wöchentlich geben. Diese Entwicklung mit immer deutlicheren Einschnitten in die Konzerttätigkeit ist eng verbunden mit dem im 19. Jahrhundert wachsenden Bedeutungsverlust der Carillonkunst in Europa. 1891/92 wurden Turm und Carillon generalüberholt, und der Posten des Carillonneurs blieb unbesetzt. 1893 übernahm Richard Thiele das Amt und übergab es 1903 seinem Sohn Eugen Thiele. Beide spielten zu den Gottesdiensten und gaben wöchentlich ein halbstündiges Sonntagskonzert. Das Repertoire der Konzerte umfaßte geistliche und weltliche Musik, größtenteils Bearbeitungen der jeweiligen Carillonneure für das Instrument. Hauptsächlich waren dies Choräle, geistliche Lieder, Arien und Volkslieder. Seit 1921 gab es unter Hans Siepert wieder wöchentlich 2 Konzerte, das traditionelle Sonntagskonzert nach dem Gottesdienst und die sogenannten Vorträge auf dem Glockenspiele am Mittwoch. Die Mittwochsprogramme enthielten sechs bis vierzehn Stücke, die sich nach den wiederkehrenden Ereignissen des Jahres und der Kirchenkalenders richteten. Siepert füllte drei Hefte mit über vierhundert kurzen, auf einem Notensystem geschriebenen Bearbeitungen. Den Hauptteil der Vortragsstücke bildeten Kirchenchoräle: Wie schön leuchtet der Morgenstern, Christ ist erstanden, Komm heiliger Geist und Volkslieder: Blaue Luft - Blumenduft. Es war ein König in Thule, Mein Vater war ein Wandersmann. Zum Repertoire gehörten ebenfalls einige Märsche: Der Torgauer, Der Hohenfriedberger und Bearbeitungen klassischer Werke: Largo aus der Oper Xerxes von Händel, Andante aus der Klaviersonate op. 14 Nr. 2 von Beethoven, Pilgerchor aus der Oper Tannhäuser von Wagner, das Lied O Täler weit, o Höhen von Mendelssohn. Wie seine Vorgänger kannte Siepert allerdings weder Originalwerke für Carillon, noch verfaßte er selbst welche. Ab 1922 wurden regelmäßig Turmmusiken mit dem Carillon und Bläsern gegeben. Siepert warb regelmäßig mit ca. 200 gedruckten Programmzetteln für seine Konzerte,² zu denen teilweise tausende Besucher die Straßen um die Kirche belagerten (Abb. 1). Allerdings findet sich im Archiv der Parochialkirche auch eine Reihe von Beschwerdebriefen, z.B. schreibt Herr

7 ibid. S. 85 8 vgl. Heinz Siepert Das Glockenspiel der Evangelischen Parochialkirche zu Berlin Typoskript, 1940 dem Archiv der Parochialkirche gestiftet S. 69

I. Es fällt außerordentlich schwer, Klangkunst auf einen bestimmten musikalischen Gattungszusammenhang zu projizieren. Keiner der Gesichtspunkte, die einen klassischen Gattungszusammenhang konstituieren, macht im Angesicht der vielgestaltigen künstlerischen Konzepte und Formen, die sich hinter dem Begriff Klangkunst verbergen, eigentlich Sinn: Besetzung, Text, Funktion, Aufführungsort etc.. Hier scheinen sämtliche Ordnungssysteme der europäischen Tradition artifizieller Musik außer Kraft gesetzt. Was Klangkunst ist, wissen immer nur jene, die sie ausschließen, sei dies bei Ausstellungen oder aber der Verteilung von Tantiemen. Ausgrenzungen sind möglich, aber keine Eingrenzungen. Das allerdings dürfte auf sehr viele musikalische Formen der Neuzeit zutreffen. Der Kanon künstlerischer Arbeitsweisen und Produktion hat im 20. Jahrhundert einen atemberaubenden Prozeß der Öffnung in jeder Hinsicht (Material, Orte der Präsentation, Verhältnis von Künstlern und Publikum, Verflüchtigung des Kunstgegenstandes) durchlaufen. Was Kunst sei und was nicht, entzieht sich dabei zunehmend der Definitionsmacht akademischer Kunst- und Musikwissenschaften, die in ihrem latenten Traditionsbewußtsein einst normierende Funktion hatten und kulturelle und künstlerische Formen hierarchisch geordnet wissen wollten. Warum aber finden Begriffe – wie der der Klangkunst – so vehement Eingang in den Sprachgebrauch entsprechender Diskurse? Sie besetzen künstlerisches Terrain, fungieren bisweilen gar als Kampfbegriffe gegen vermeintlich überkommene Formen oder werden erstmals als Schwerpunkte in die Vergaberichtlinien öffentlicher Kunstförderung² aufgenommen. Warum beflügeln sie akademisches Interesse und Forschungen, geben Festivals, Symposien, Fachzeitschriften oder Radiosendungen Anlaß zur Präsentation und Diskussion? Dieses Bündel von Fragen ist sicherlich kaum zufriedenstellend zu beantworten. Zu viele Dimensionen des aktuellen Kunstprozesses wären angesprochen. Interessant scheint es aber allemal, weil eine Fragerichtung avisiert ist, die latent den vielfältigen Diskussionen um Klangkunst inhärent ist, aber nie eigentlich ausgesprochen wird: Klangkunst im Kunst- bzw. Kulturbetrieb. Die weiter oben genannten Tendenzen zeugen in der Konsequenz vom Wunsch einer wie auch immer gestalteten Institutionalisierung dessen, was notdürftig mit dem Begriff Klangkunst umrissen ist; die Gründung und Unterhaltung spezieller Einrichtungen bzw. Fonds, Etats, Sendestrukturen, Lehrstühle etc. – die gesellschaftliche Anerkennung eines vagen, sich eigentlich permanent verändernden künstlerischen Feldes, das im Kanon der etablierten Zusammenhänge beargwöhnt und gleichsam von magnetischer Anziehungskraft ist, weil eigentlich nicht faßbar, aber als Indiz des dynamisch sich verändernden Kunstprozesses von den Platzhaltern des traditionellen Kulturbetriebes keinesfalls zu vernachlässigen.

1 Helga de la Motte-Haber Klangkunst. Alternative oder Ergänzung zur traditionellen Präsentationsform von Kunst In: Alternativen Veröffentlichungen des Institutes für Neue Musik und Musikerziehung Darmstadt Bd. 38 hrsg. v. Johannes Fritsch (Schott) 1998 S.55 2 Seit 1997 hat die Berliner Senatsverwaltung für Wissenschaft, Forschung und Kultur den Begriff Klangkunst als Schwerpunkt in den Katalog ihrer Förderrichtlinien im Bereich Ernste Musik für die sogenannte Freie Musikszene aufgenommen.

Podiumsdiskussion Klangkunst Institutionalisieren? Symposium Klang-Kunst-Räume am 10.10.1998 Alle weiteren Statements im Text entstammen ebenfalls dieser Diskussion.

...ich bin ein Propagandist des Anti-Institutionellen, nicht-gattungsmäßigen Begrenzens oder Definierens, ... Klangkunst ist für mich ein mehr oder weniger praxisbezogen beschreibender Sammelbegriff für ... eigentlich sehr Einschlägige Sammelbegriff für Arbeitsformen ... Typisch dabei ist ... daß kommen Bassiste Künstler, (Im)materiell, Video als Musiker, ... sind bildende Künstler, Filmemacher, wer auch immer ... Ecken kommen: bildende Künstler, die alsunterschiedlichsten ... diakustiker, wer auch immer, es sind Künstler, die sich in der zur Musiker ... bei Klang konstitutiv mitbenutzen, Klangkunst äußert sich nicht re- ... Form grenzüberschreitend oder intermedial, Klangkunst sollte nicht re- ... duziert sein auf Klanginstallationen, Klangkunst im Bau sondern ... Klang Skulptur oder womöglich Klangkunst im Bau sondern ... sollte sehr wohl temporäre, eventhaftig, performative For- ... Formen mit einbeziehen, d.h. netzwerkhaft geschaltet, ... men medienkunstlerischer Art etc. Matthias Osterwold

Klangkunst im Berliner Kulturbetrieb – die singuhr – hœrgalerie in parochial

Susanne Binas

Jutta Ravenna

Symposium »Klang-Raum-Musik« 10.10.1998

Man müßte eine Musique d'ameublement produzieren, genauer gesagt, eine Musik, die an den Geräuschen

der Umgebung teilhat und auf diese Rücksicht nimmt. Ich stelle sie mir folgendermaßen vor:

melodiös, die Geräusche der Gabeln
und Messer abschwächend,
sie jedoch nicht dominierend.

Erik Satie, 1920

Warum sollte man Rücksicht auf die Geräusche von Messern und Gabeln nehmen?

Satie behauptet das.
Und er hat Recht.

Andernfalls würde die Musik Mauern errichten müssen, um sich selbst zu verteidigen,

um ein Glas Wasser trinken zu können.

Mauern, die beständig instandgesetzt werden müßten, und über die man sich, selbst

die Katastrophe herausfordernd, hinwegsetzen müßte.

Es ist offensichtlich eine Frage,
ob intendierte Handlungen

von jemandem in Relation zu den nichtintendierten der Umgebung gebracht werden.

John Cage, 1961

Kontextbezogenheit

In einigen meiner Arbeiten geht es darum, Musik in einen bestimmten Kontext zu stellen. In der Suche nach Räumen manifestiert sich die Suche nach einem Kontext, d.h. einem realen Bezugssystem, in welches die Arbeit gestellt werden kann. Hierbei unterscheide ich zwischen Räumen mit einem intakten funktionalen Innenleben und funktionsfreien Orten. Mit musikalisch nicht besetzten, funktionsfreien Räumen wie z.B. dem natürlichen Ambiente oder einer zum Großstadtidyll gewordenen Stadtbrache, Baulücken, verwilderten Bahngeländen, stillgelegten Schwimmhallen, leerstehenden Fabrikgebäuden, Bau- und Kriegsruinen bieten sich Spielräume für die ungestörte ästhetische Praxis. Manchmal ist es eine bestimmte akustische Geräuschsphäre, manchmal hingegen die Ruhe, die mich an einem Ort anzieht. Auch ein in regelmäßigen Abständen über einen Ort hereinbrechender Lärm hat mich schon fasziniert. Auf der optischen Ebene sind es andere Merkmale: Die infolge von Witterungseinflüssen entstandene Patina auf der Fassade, das Bröckeln des Gesteins von der architektonischen Form und das mit voranschreitender Zeit zunehmende Verwildern und Überwuchern durch zufällig herbeigeflogene Pflanzensamen, die sich zu Gräsern, Ranken und Büschen an funktionslos gewordenen Orten entwickeln, lösen Erinnerungen aus und wirken zunächst als Inspiration. Später werden sie als räumlicher und akustischer Kontext zum wichtigen Bestandteil bei der Inszenierung einer künstlerischen Idee. (Das ist natürlich nicht zwangsläufig der Fall: Es gibt auch Klangskulpturen, die souverän sind. Diese funktionieren fast überall, egal in welchem Kontext sie präsentiert werden.) Andererseits ermöglichen Klangskulpturen an intakten und belebten Orten wie Brücken, Parks, öffentlichen Plätzen, Bahnhofshallen, in S-Bahnen, Shopping Malls, Universitätsgeländen, Krankenhäusern und Schulen die spannende Integration in Alltagsprozesse. Der alltägliche Lärm der Geräusche vor Ort bildet den akustischen Kontext, zu dem kritisch Stellung bezogen werden kann, in den es einzudringen oder den es zu überlagern gilt. Zunächst erfordert dies eine akustische Bestandsaufnahme, um die Voraussetzung dafür zu schaffen, – im Sinne John Cages – »intendierte Handlungen in Relation zu den nichtintendierten der Umgebung zu bringen«. Deswegen ist auch der soziale Kontext als außermusikalischer Faktor – wie zum Beispiel die Arbeits-, Bildungs- oder Erholungszusammenhänge in Büros, an Universitäten oder in Parks – für mich von immenser Bedeutung. Dieser wird zum zusätzlichen Steuerelement für die musikalischen Parameter meiner Musik. Bestimmte soziale Vorgänge erfordern beispielsweise leise Klänge, andere das Gegenteil. Manche Situationen erfordern Klangprozesse mit vielen Pausen, um das akustische Umfeld durchscheinen zu lassen, andere andauernde Schallfelder. Darauf werde ich später noch genauer eingehen. Mit dem Einbrechen von Klangkunst in Alltagszusammenhänge verbindet sich ganz konkret die Auseinandersetzung mit der Sozialstruktur des Ortes: Hausmeister, Sicherheitsangestellte für den zivilen Wachschutz, BibliothekarInnen, Bootsverleiher, LehrerInnen, Geistliche und Ordnungsbeamte werden zum Dialogpartner oder zu Gegnern des eigenen Engagements. Meine Sensibilität als Klangkünstlerin für die ortsgegebenen Sozial- und Funktionsstrukturen bildet die Voraussetzung dafür, in solchen ungewohnten Zusammenhängen überhaupt arbeiten zu können. Die entscheidende Frage

ist jedoch, ob es mir darum geht, soziale Abläufe zu berücksichtigen, mit einzubinden, abzubilden, zu unterlaufen oder zu stören. Eine gesellschaftliche Einbindung von Kunst erfolgt oft um den Preis ihrer Störqualität. Oft ist die künstlerische Idee im öffentlichen Raum nur in abgeschwächter Form realisierbar. Die Rolle der Klangkunst sehe ich trotzdem als kritischen Kommentar künstlerischer Reflexion innerhalb eines sozialen, architektonischen und akustischen Kontextes und nicht in der Funktion, die Kunst im öffentlichen Raum oft erhält: nämlich der eines gefälligen, geistreichen Aperçus. Ich fühle mich eben nicht einer Ästhetik des »schönen Scheins« verpflichtet. Die Geräusche sowie die optische Erscheinungsbild meiner Klangskulpturen sollten keinesfalls das akustische Kompensat mißglückter Stadtarchitektur und konfliktreicher Soziostrukturen bilden, sondern vielmehr die Realität eines spezifischen Ortes, so wie er ist, mit neuen künstlerischen Mitteln sinnlich erfahrbar machen.

Status Quo Die Mauern zwischen einer für den abgeschirmten Konzertsaal konzipierten Musik und der Geräuschsphäre des Alltags existieren jedoch im allgemeinen auch heute noch. Abgesehen von der nichtssagenden Dauerberieselung durch Muzak in Shopping Malls, Restaurants, Wartehallen und Aufzügen, treffen Klänge und Geräusche des äußeren akustischen Umfelds sowie des akustischen Designs der Gebrauchsgegenstände meist ganz unvermittelt auf unser Ohr. Wär man eine Hörsituation schaffen, welche die Geräusche der Umgebung miteinbezieht, so ist es heute technisch nun ein weiteres möglich, ein spezifisches akustisches Material zu generieren, das als Klanginstallation in den öffentlichen Raum implantiert wird. Im urbanen Rauschen verbirgt sich hierfür eine Vielzahl von Anknüpfungsmöglichkeiten. Dies erzeugt eine auditive Wahrnehmungsdichte aus Hintergrundgeräuschen wie Straßenlärm, Baulärm, Stimmengewirr und unzähligen anderen Quellen, die nur mit viel Geduld überhaupt differenzierbar sind. In meinen Klanginstallationen versuche ich das hörbar zu machen, was das selektive Hören gewöhnlich ausblendet. Die Geräusche der Umgebung werden hierbei ebenso wichtig wie die Eigengeräusche meiner Klangskulpturen. Der Begriff »Feld« bezieht sich in meiner Arbeit auf ebendiesen akustischen Kontext. Fernab von den zu verteidigenden Mauern, von denen bei Cage die Rede ist, möchte ich eine Musik schaffen, welche ihr Umfeld nicht dominiert, sondern miteinbezieht. Intentionslos, bar jeder ästhetischen Gelüste, fließt ein Strom zufälliger Passanten an meiner Klanginstallation vorbei: ein Zufallspublikum aus unterschiedlichen Bevölkerungsschichten und Altersgruppen. Jenseits von Erklärungen hat hier die Unmittelbarkeit das Wort.

Temporär – Stationär oder: Ein Hördenkmal? Ich spreche hier besonders von Klanginstallationen für den Außenraum. Die Inbesitznahme des öffentlichen Raumes durch die Klangkunst kann sowohl temporär als auch stationär – als permanente Installation – erfolgen. Oftmals ist Klangkunst lediglich als temporäres, akustisches Ereignis vorhanden. Die akustische Intervention mit Hilfe einer temporären Installation von Geräuschen im öffentlichen Raum folgt der kritischen Selbsterkenntnis einer Kunst, die den Ewigkeitsmythos hinter sich gelassen hat. In der Vorläufigkeit und Vergänglichkeit erzeugt sie lediglich das Übergangsstadium eines Ortes von einem Zustand in den nächsten. Ihr Erscheinen erfolgt unter dem Vorbehalt, bald wieder zu verschwinden. Zugrundegelegt ist hier ein ganz einfaches Wahrnehmungsgesetz: sich bewegen zu müssen, um wahrgenommen zu werden. Ihre historischen

Wurzeln hat die temporäre Klanginstallation oder Klang-Inter-Vention mit ihrem Impetus des Sich-dazwischen-Schaltens oder Sich-Einmischens in gesellschaftliche Zusammenhänge in den Formen der Events, Happenings und Aktionen der Sechziger Jahre. Der Handlungscharakter wandte sich damals – abgesehen von der Auflösung des traditionellen Werkbegriffs – gegen das Vermarkten von Kunstwerken als Ware auf dem Kunstmarkt. Die dauerhafte Inbesitznahme eines Ortes durch eine variabel programmierte Klangskulptur würde anfangs vielleicht zur Irritation der alten und zum Einschleifen neuer Hörgewohnheiten führen. Umbrandet von einer permanent sich wandelnden realen Umgebung, könnte sie jedoch bald selbst Gewohnheit werden. Hier stellt sich mir die Frage: Wie lange dauert es, bis eine permanent installierte Klangskulptur – auch wenn sie so programmiert ist, daß sie immer wieder anders klingt – im öffentlichen Raum überhört wird? Im Gegensatz zum »Eingesperrtsein« im Konzertsaal kann der Hörer in der Wildnis der Großstadt, befreit von Zwängen des Anstands, jederzeit der Musik entfliehen: Die Ströme von Passanten und Verkehr, ihre Verdichtungen, Stauungen und Auflösungen, ihre Tempi und Zeitnester sind für die Wahrnehmungssituation der Klanginstallation von immenser Bedeutung. Wird sie, eingebettet in Alltagszusammenhänge, zur »musique d'ameublement« – zum klingenden Großstadtmobiliar?

Hörsituation: einige Beispiele aus meiner künstlerischen Arbeit Die Wahrnehmungssituation vor Ort ist von unterschiedlichen Faktoren geprägt: ein bestimmtes Licht, ein besonderer Duft oder Geruch, Temperatur und Luftfeuchtigkeit, mein eigenes Befinden, die Geräusche. Bevor ich mich auf die Suche nach einem bestimmten Klangmaterial für den entsprechenden Raum mache, inspiziere ich den Ort und die Menschen. Der architektonische, soziale und akustische Kontext, in dem meine Klangskulptur eingebettet werden soll, bildet das wesentliche Ausgangsmaterial für meine Klänge und für die Art und Weise, wie sie gehört werden können. Bedingt durch architektonische und funktionelle Setzungen herrscht eine Situation des Verweilens,

If you lead a good life,
say your prayers,
and go to church,
when you die,
you will go to
SOUTH DAKOTA

ARE ADULTS
UGLY CHILDREN /
UGLIER AND IN
THE DARK/

Subcircus—60 Second Love Affair

The packaging for this CD single works simply and effectively. The manipulation
of the two photographs to produce large areas of flat, strong background color,
which tonally complement the figure, has added to the images' graphic impact.
The device of cropping both images through the head of the subject creates
a further startling visual link between the two. The computer-till-receipt/neon-
newsflash style of the typeface used—Dot Matrix—also gives a subliminal
immediacy to the lyrics printed on the sleeve to underline the fleeting nature
of the song's theme.

SUBCIRCUS/ 60 SECOND LOVE AFFAIR/
YOUR SILENCE HAS A SOUND / DON'T YOU
DISAPPEAR IN A MAGICAL PUFF OF SMOKE /
IT LOOKS LIKE WE JUST MIGHT MAKE IT
THROUGH / THE NEXT SIXTY SECONDS / IT
LOOKS LIKE WE HAVE FOUND SOMETHING
SO NEW / AND IT WILL PROTECT US
FALLING /

Designer
Rob Chenery

Art Director
Rob O'Connor

Photographer
Michele Turriani

Design Company
Stylorouge

Country of Origin
UK

Description of Artwork
Packaging for the CD
single of *60 Second Love
Affair* by Subcircus.

Dimensions
120 x 120 mm
4³/₄ x 4³/₄ in

Format
CD single

Designer
Dom Raban

Design Company
Eg.G

Country of Origin
UK

Description of Artwork
24-page color brochure
overprinted with opaque
white ink on 230 micron
Colourmaster Grey paper.

Page Dimensions
205 x 205 mm
8 x 8 in

Format
Brochure

University of Sheffield School of Architecture

The layout for this brochure has been developed from the proportions of the golden section, an appropriate starting point considering its architectural theme. Blocks of strong color have been used to enliven technical imagery, such as site overview drawings, aerial photographs, and cross-sections. This, combined with the use of white text, gives the work consistency even though the shapes and layouts are irregular.

Special Production Techniques

The brochure has been printed in four colors, overprinted with an opaque white ink that unites the different aspects of the design. This and the subtle contrast of white ink on off-white paper gives this publication a strong visual and tactile presence.

Artur – Forum für Kunst und Kultur
(see following spread for description)

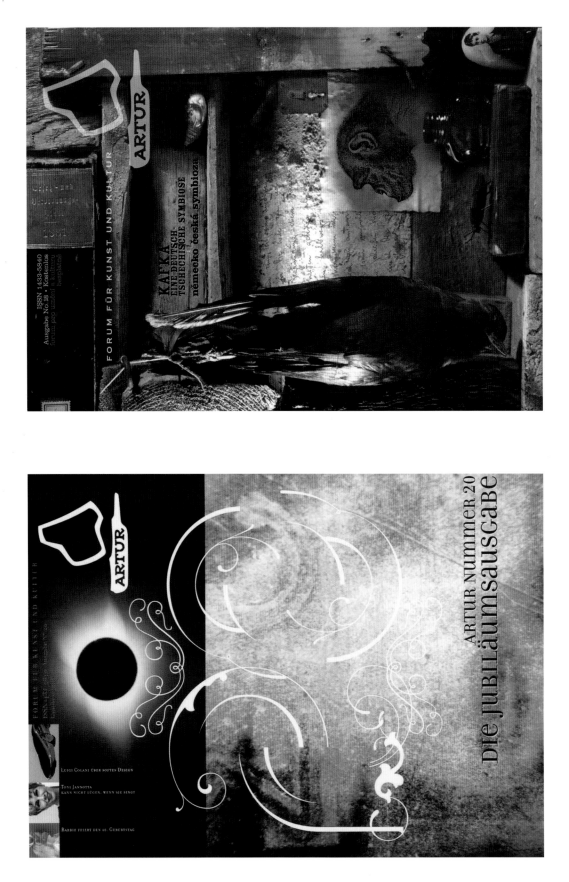

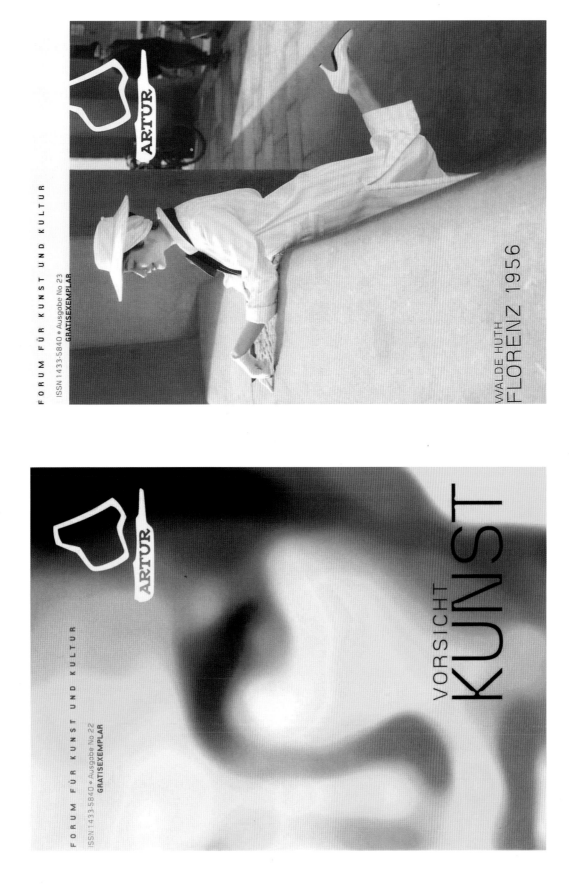

FORUM FÜR KUNST UND KULTUR

ISSN 1433-5840 • Ausgabe No 23
GRATISEXEMPLAR

ARTUR

WALDE HUTH
FLORENZ 1956

FORUM FÜR KUNST UND KULTUR

ISSN 1433-5840 • Ausgabe No 22
GRATISEXEMPLAR

ARTUR

VORSICHT
KUNST

Designers
Ilja Sallacz, Carina Onschulko (issue 19)

Art Director
Ilja Sallacz

Illustrators
Ilja Sallacz, Carina Onschulko (issue 19)

Photographers
Bernd Hohlen, Walde Huth (issue 23)

Editor
Sonja Hense

Design Company
LIQUID Agentur für Gestaltung

Publisher
Thomas H. Rossmann

Country of Origin
Germany

Description of Artwork
A quarterly magazine about art and culture published in southern Germany. Previous spread: covers from issues 18, 20, 22, 23. This spread: cover and inside pages from issue 19.

Page Dimensions
210 x 292 mm
8¼ x 11½ in
Opening to a maximum width of 840 mm, 33 in

Format
Magazine

Artur—Forum für Kunst und Kultur

No two issues of this magazine are alike: the content, design, number of colors printed, and paper, all change each time. Sometimes in four-color, sometimes in monochrome, this open-ended brief allows the designer free rein to make each issue as exciting and provocative as possible. It also gives the magazine visual and textural diversity. Set against this freedom is the magazine logo, its constancy identifying the magazine and highlighting the variety in the rest of the publication. Its unusual and obscure shape is strong enough to transcend the subtle changes it undergoes from issue to issue.

The way the logo casts a shadow on the page signals one of the concerns of this issue: the representation of three dimensions on a two-dimensional surface.

The application of perspective to this type extends the 3D theme begun with the logo on the cover.

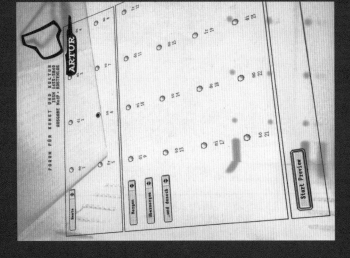

MILCHSTRASSE –
DAILY SOAP AUS CHILE
La Silla – Der Gipfel der Sternseher.

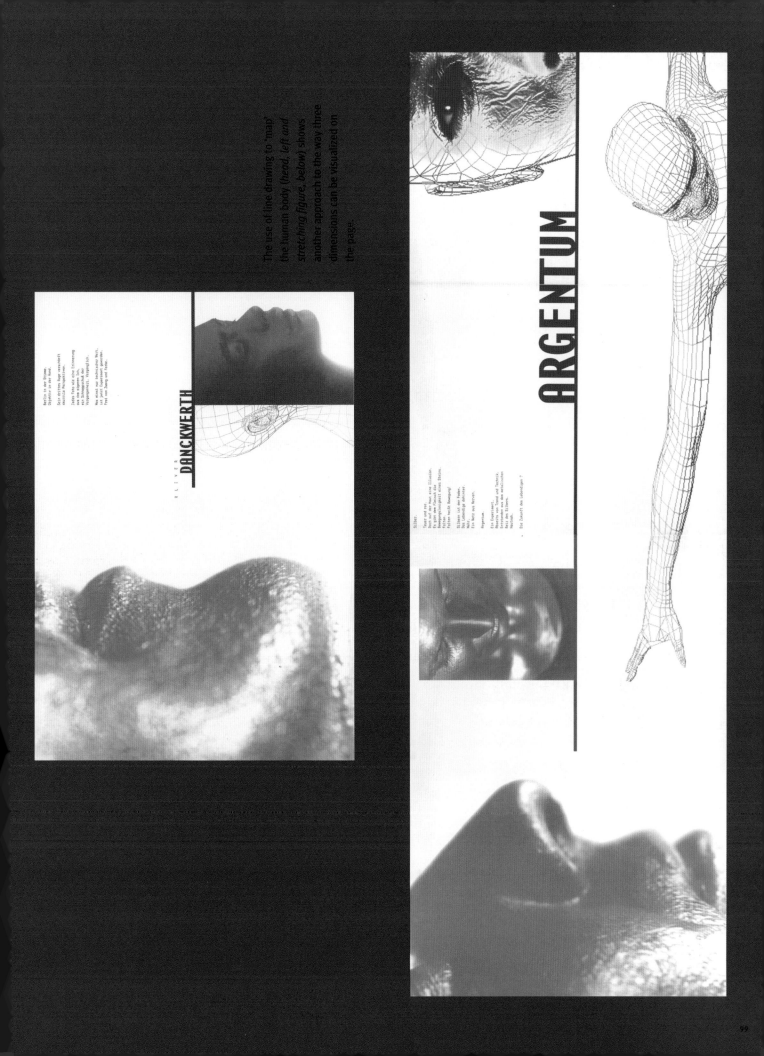

The use of line drawing to 'map' the human body (head, left and stretching figure, below) shows another approach to the way three dimensions can be visualized on the page.

ARGENTUM

OLIVER DANCKWERTH

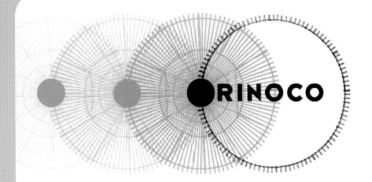

LOW-BANDWIDTH: ESPAÑOL | ENGLISH | PORTUGUÊS

HIGH-BANDWIDTH: ESPAÑOL | ENGLISH | PORTUGUÊS
Requerimientos | Requirements | Requisitos
PC Explorer 4.0+, PC Navigator 4.0+, Mac Navigator 4.0+
Shockwave 7.0, Flash 4.0, Real Media G2 Player
Mejor visualización a 800 x 600 o mayor

UN PROGRAMA DE LA FUNDACIÓN CISNEROS

Orinoco Online

In this website design, the consistent graphic presentation of diverse images and cultures brings them together with a clear and pleasing aesthetic. It succeeds in making relatively obscure information both appealing and accessible. The non-linear structure of the site, with information grouped in constellations rather than hierarchically, is derived from the way in which the indigenous cultures conceptualize the universe. This integrated approach extends to the color palettes and other design elements, all of which were inspired by different aspects of the cultures featured.

The circular navigation graphic is intended to encourage a more intuitive exploration of the site. At first a little unfamiliar, this device mediates the way in which the site is viewed, allowing each visitor to find their own route between the different cultures.

In earlier times, men did not ʜ
fire. A woman name Kawao ov
the fire. She would hide it in h
stomach and would not show
anyone, not even her husban
When she was alone, Kawao w
turn herself into a frog, open
mouth and spit the fire under
cooking pots. When her husba
arrived, food was always read
would ask: how did you do it?
she would answer: I cooked t
food under the sun. She trick∢
him and he believed her. Wha
did not know was that when ʜ
left, he turned himself into a
jaguar.

Designers
Rafael Esquer, Mariana
Saddakni, Chakaras Johnson

Creative and Art Direction
Rafael Esquer

**Creative and Project
Management**
Angela Fung

Programmers
Harsha Kalidindi, Valerie
Valoueva, Stephen Chu

Audio/Video Editor
Paul Bozymowski

Executive Producer
Hillary Leone

Editorial Director
Lelia Delgado

Design Company
@radical.media

Country of Origin
USA

Description of Artwork
A website (www.orinoco.org)
for the Fundación Cisneros
to help promote interest,
knowledge, and support for
the indigenous populations
of southern Venezuela.

Dimensions
800 x 550 pixels

Format
Website

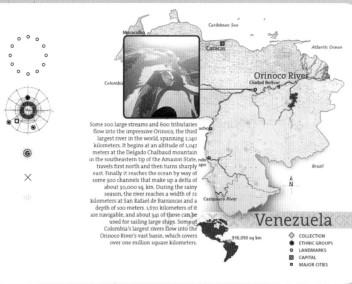

Some 200 large streams and 600 tributaries flow into the impressive Orinoco, the third largest river in the world, spanning 2,140 kilometers. It begins at an altitude of 1,047 meters at the Delgado Chalbaud mountain in the southeastern tip of the Amazon State, and travels first north and then turns sharply east. Finally it reaches the ocean by way of some 300 channels that make up a delta of about 30,000 sq. km. During the rainy season, the river reaches a width of 22 kilometers at San Rafael de Barrancas and a depth of 100 meters. 1,670 kilometers of it are navigable, and about 341 of those can be used for sailing large ships. Some of Colombia's largest rivers flow into the Orinoco River's vast basin, which covers over one million square kilometers.

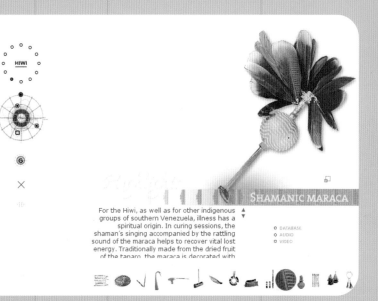

For the Hiwi, as well as for other indigenous groups of southern Venezuela, illness has a spiritual origin. In curing sessions, the shaman's singing accompanied by the rattling sound of the maraca helps to recover vital lost energy. Traditionally made from the dried fruit of the taparo, the maraca is decorated with

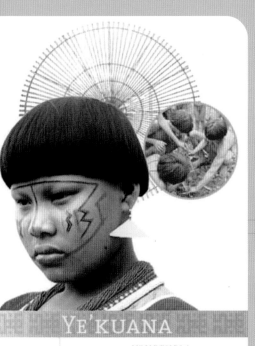

YE'KUANA

VENEZUELA

The moon dwelled in the body of a grand shaman. When he died, she was free to wander in space but instead returned to the earth to eat his incinerated bones. When the shaman's relatives discovered this outrage, they attacked the moon with arrows but the arrows fell harmlessly to the earth. The moon tried to evade the arrows by hiding in the clouds but at last one arrow penetrated and her blood spilled to the earth. From the drops of her blood the Yanomami were born.

YANOMAMI

VENEZUELA

○ CULTURE
○ OBJECTS IN THE COLLECTION

(0.001 SPEAK BITTERNESS)

FORCED ENTERTAINMENT

forced entertainment

**WHAT STORIES WOULD YOU TELL A SMALL CHILD?
WHAT STORIES WOULD YOU TELL A PREGNANT WOMAN?
WHAT STORIES WOULD YOU TELL A DYING MAN?**
(Showtime, 1996)

Born out of Sheffield, an ex-industrial city in the north of England, our work is an attempt to map contemporary experience in a theatre language which both comes from and responds to the times. Central to the work is our exploration of the struggle for coherence in a life, or in a culture - a trying to make sense of what we see and what we feel. The themes we have returned to have been life in cities, identity, love, fragmentation, the need to confess. The theatrical qualities we come back to are those of intimacy, vulgarity, black comedy and gentle optimism.

In thirteen years the ground we have mapped has been shifting constantly - a jumpy comical channel-hop through the dreams and stories of modern life. The work is emphatically group work - created out of dialogue, rehearsal, improvisation, accident, argument and luck. Born from an intimacy that doesn't have a name.

**MODERN LIFE, MODERN LIFE...
DOGS TRAPPED IN THE BACKS OF CARS,
TV DINNERS AND THOSE CANS YOU JUST
CAN'T OPEN... LIKE, ER, NO ONE BELIEVES
IN THE OLD GODS ANYMORE**
(Pleasure, 1997)

And if stories once seemed like simple things - tidy structures to frame and make sense of the world - now they can seem like much more complex and problematic objects. Born in a house with the TV always on, living in a city full of disconnected lives, so that sometimes, in the dead of night, it's impossible to believe in a thing called stories at all.

In a dream some person takes all the stories that you cling to, slips them in a cloth bag, lays it on a table [and] bangs it sixteen times with a hammer. The contents [of] the bag are broken, poured on the floor - people, fragme[nts], notions, pieces. No way to [fix] it all. In a world like this [...] the performance is never m[ore] and never less than a vital shuf[fle] of the pieces, a rearrangem[ent], a magic of ruins.

fe SHOWTIME

First performed in 1996 **SHOWTIME** is Forced Entertainment's fifteenth major theatre project, a comical piece in which the concerns of adult life - especially death - are played out in a visual language drawn in part from children's picture books & pantomimes.

A piece about stories, and what they are for, **SHOWTIME**'s concern is also with theatre itself - with the nature of our demands as spectators, with the construction of illusion as well as with the desire for order, sense and coherence in our lives.

this act of rearrangement
t we invite you to this
ning - a trying to make
se of certain fragments
've inherited - the dreams
d, bad and indifferent
t have haunted us at
tain times.

hope you enjoy the work.

**WE'RE GUILTY OF FRAUD AND FORGERY,
WE'RE GUILTY OF COLDNESS AND SPITE,
WE LAUGHED WHEN WE PROBABLY SHOULD
HAVE CRIED, WE TOLD SOFT STORIES TO
CHILDREN, WE TOLD SOB STORIES TO ANYONE
THAT WOULD LISTEN, WE WROTE ENDLESS
AND TERRIBLE POEMS ABOUT CEAUCESCU,
WE HAD STREET LUCK, WE LOVED TO GET
LOST TOGETHER, OUR MOTTO WAS
YES AND NOW AND HERE**

(Speak Bitterness, 1995)

© Tim Etchells 1998

Designer
Dom Raban

Photographer
Hugo Glendinning

Design Company
Eg.G

Country of Origin
UK

Description of Artwork
12-page mono brochure
supplied with 6 do-it-
yourself color stickers.

Page Dimensions
105 x 148 mm
4¹/₄ x 6³/₄ in

Format
Brochure

Forced Entertainment

This witty and imaginative retrospective brochure for an innovative theater company succeeds in both entertaining and intriguing, all within a tight budget. A spirit of experimentation is encouraged through the use of cost-effective one-color printing combined with the inclusion of six colored stickers for the reader to add to the design. The do-it-yourself nature of the brochure makes it a memorable publication.

OTHER WORK PAST PROJECTS

DURATIONAL PERFORMANCES

Performances lasting 6-12 hours, presented in spaces like railway arches, cellars and the changing rooms of abandoned gymnasia have allowed the company to work with improvisation, task-based performance and the dynamic effects of exhaustion, as well as with 'audiences' that may come or go at any point. Durational works by the company include **12am: Awake & Looking Down** (1991), a performance about the playful aspects of contemporary identity, **Quizoola!** (1996) a performance of 2000 questions and answers and a marathon version of their acclaimed confessions piece **Speak Bitterness** (1995).

DIGITAL MEDIA

In collaboration with photographer Hugo Glendinning and the multimedia design team Bytehaus the company have also developed several digital projects investigating ideas around virtual space (cities, houses, databases) and the construction or exploration of narrative by individual users. Digital works include **Frozen Palaces** (CD-Rom), **Nightwalks** (CD-Rom), both due for release in 1998 and **Paradise**, an Internet collaborative writing project, which allows users to add text to a vast imaginary metropolis. **Paradise** can be found at www.lovebytes.org.uk/paradise/

INSTALLATIONS

Forced Entertainment have developed several gallery installation projects in collaboration with photographer Hugo Glendinning. **Red Room** (1993) was an investigation into the construction of narrative from performance, photographic and textual evidence. **Ground Plans For Paradise** (1995) is a model city installation comprising 1,000 empty buildings, each of them named, with accompanying photographic images of sleeping people.

FILMS

DIY (1997, 10 mins, dirs: Tim Etchells & Hugo Glendinning) is a subversive documentary made with gay artist Michael Atavar. Commissioned by Channel 4 it won a prize as best short documentary in the 1998 San Francisco Film Festival. **On Pleasure** (1997, 10 mins, dir: Alexander Kelly) is a documentary collaboration with Forced Entertainment for LWT's South Bank Show, showing them at work on their theatre piece Pleasure. **Filthy Words & Phrases** (1998, dirs: Tim Etchells and Hugo Glendinning) is a seven hour video work in which a lone woman stands at a blackboard in a deserted school-room and writes out a list of 2000 sexual obscenities. Performed by Cathy Naden the piece premiered as part of the 1998 Rotterdam Film Festival.

PAST PROJECTS

All the works are theatre performances unless otherwise indicated. Dates refer to year of creation and original touring/distribution. Many of the works have been re-staged or re-presented in the years following their creation.

1984	**Jessica in the Room of Lights**
1985	**The Set-up** National Review of Live Art (NRLA)
1985/6	**Nighthawks**
1986	**The Day that Serenity Returned to the Ground** commissioned by The Zap Club
	(Let the Water Run Its Course) to the Sea that Made the Promise
1987/8	**200% & Bloody Thirsty**
1989/90	**Some Confusions in the Law about Love**
1991	**Welcome to Dreamland** Retrospective Trilogy sponsored by The Leadmill/Becks Bier
	Marina & Lee
1992	**Emanuelle Enchanted**
1993/4	**Club of No Regrets**
	Red Room performance installation with photographer Hugo Glendinning, commissioned by ICA Live Arts/Showroom Gallery
	12 am: Awake and Looking Down eleven hour performance commissioned by NRLA
1994/5	**Hidden J**
	Speak Bitterness Durational Performance/Installation NRLA
	A Decade Of Forced Entertainment Performance/Lecture
	Ground Plans For Paradise Installation in collaboration with Hugo Glendinning for Leeds Metropolitan University Gallery and Studio Theatre
	Nights In This City Site-specific work, Sheffield
1995	**Speak Bitterness** theatre version
	Break In! Children's project in collaboration with Sheffield Theatres
1996	**Showtime**
	Quizoola! Durational Work commissioned by ICA Live Arts & National Review Of Live Art
	Frozen Palaces Digital Media R&D, in collaboration with Hugo Glendinning
1997	**Nights In This City** Rotterdam version commissioned by Rotterdamse Schouwburg & R Festival
	Paradise Internet Project commissioned by Lovebytes as part of the Channel Metropolis series
	Pleasure
1998	**Nightwalks** CD Rom in collaboration with Hugo Glendinning, commissioned by Photo 98
	Filthy Words & Phrases Seven hour video work, directed by Tim Etchells & Hugo Glendinning

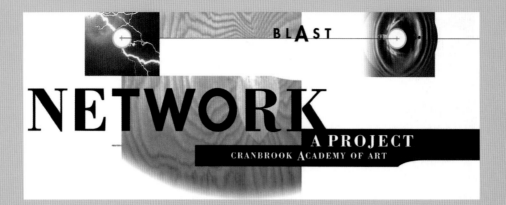

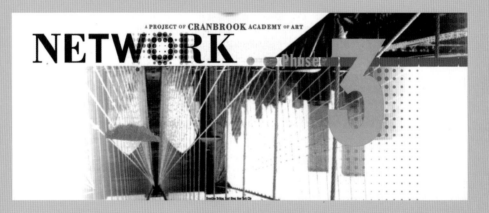

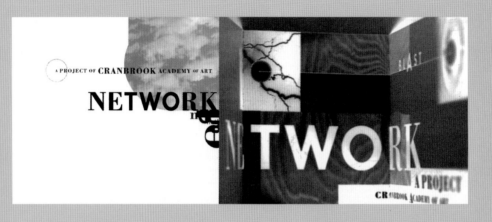

At first glance
deceptively simple,
the logotype is in fact
composed of various
typefaces.

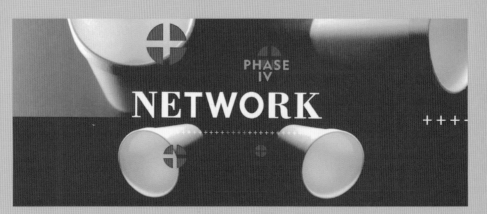

Network Gallery

The distinctive logotype allows the designer to present many of the different visual aspects of the gallery on each card while maintaining a sense of continuity. The success of this strategy can be seen, in particular, in the fifth card (*below*) where a strikingly different approach to the photography and a change in format have been successfully accommodated. All these two-color cards effectively and economically promote the gallery and reflect the fact that it shows a wide range of work.

Designer
Brad Bartlett

Art Director
Brad Bartlett

Photographer
Brad Bartlett

Art College
Cranbrook Academy of Art

Country of Origin
USA

Description of Artwork
Series of cards to announce the opening of the Network Gallery, Cranbrook Academy of Art.

Dimensions
Phases 1–4 (*opposite*):
254 x 101 mm
10 x 4 in
Phase 5 (*right*):
140 x 197 mm
$5^1/_2$ x $7^3/_4$ in

Format
Cards

Vestigial Appendage, 1962
Oil on canvas, 72 x 93.5 in.
The Museum of Contemporary Art, Los Angeles
The Panza Collection

Where did he get his ideas for this painting?

James
ROSENQUIST

Born 1933 in Grand Rapids, North Dakota
Lives in New York City

Designer
Danielle Foushee

Art Director
Danielle Foushee

Country of Origin
USA

Description of Artwork
A series of Family Gallery
Guides for the Museum of
Contemporary Art, Los Angeles.

Page Dimensions
254 x 305 mm
10 x 12 in

Format
Museum Gallery Guide

MOCA Family Gallery Guides

The bold setting of each artist's work and the accompanying
typography against a white ground draws together image and text
in this distinctive series. An uncomplicated device, but it allows the
designers to sustain a stylish solution throughout a large number
of titles. The skill in creating eye-catching typography out of a small
amount of information and subtle color combinations shows that
often simple solutions are the most flexible.

Below and opposite: printing type in colors drawn from the artwork places the emphasis on the artist, rather than the design, and gives each guide an individual feel.

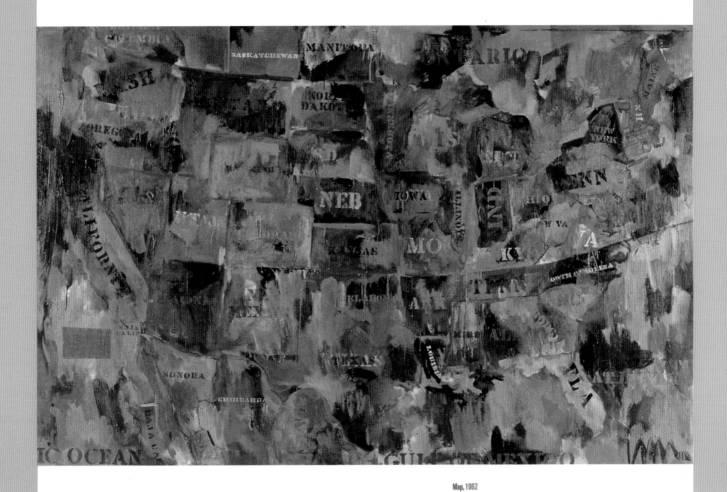

Map, 1962
Encaustic and collage on canvas, 60 x 93 in.
The Museum of Contemporary Art, Los Angeles
Gift of Marcia Simon Weisman

WHAT MAKES THIS
A WORK OF ART
?

Jasper JOHNS
born 1930 in Augusta, Georgia
lives in New York City

Haarlem Goes Missing

The style of illustration, the simple integration of typography and images, and the physical construction of this joyous project all imbue it with immense charm. The pages can be viewed as a sequence of double-page spreads or, as the book concertinas out into a long frieze, as a series of connected images on a single surface charting the character's progress through the story. Apparently a children's story, it is also a witty allegory for adults.

Special Production Techniques

Silkscreen printing, as used in this work, involves the application of different colored inks which build up, layer by layer, into the complete image. The inks may be opaque or translucent, allowing the colors beneath to show through.

Haarlem was a little brown and white dog.... ...who secretly longed for a more colourful existence, so...

...on Wednesday, he iced an enormous cake... ...then he chilled out for hours and hours at the ice rink...

Designer
Caroline Glicksman

Illustrator
Caroline Glicksman

Art College
University of Brighton

Country of Origin
UK

Description of Artwork
Screenprinted concertina-bound artist's book

Page Dimensions
150 x 150 mm
5⁷/₈ x 5⁷/₈ in

Format
Limited edition artist's book

...e went under cover in the park...

HAARLEM!

Haarlem!

...on we

...o secretly longed for a more colourful existence, so...

HAARLEM
GOES
MISSING

By
Caroline
Glicksman

111

Crossing Boundaries: Jamex and Einar de la Torre, Steven La Ponsie, and Ronald Gonzalez

Designer
Sibylle Hagmann

Art Director
Sibylle Hagmann

Design Company
TypoStudio

Country of Origin
USA

Description of Artwork
Catalog and invitation for

a fine-art exhibition entitled
'Crossing Boundaries.'
The invitation includes the
program of events scheduled
during the show.

Page Dimensions
Catalog: 216 x 241 mm
8⅛ x 9½ in
Invitation: 142 x 159 mm
5⅝ x 6¼ in

Formats
Catalog and invitation

Crossing Boundaries

The bold use of a slab serif typeface combined with subtle color fades around the edges of the catalog cover (*opposite*) and on the front of the invitation (*left*) clearly identifies this event—a simple and effective solution. The use of faded color is picked up on the inside of the invitation (*below*), in which the unusual and irregular positioning of the text in and over the edges of the white cutouts brings a distinctive quality to the list of exhibition talks and workshops.

Special Production Techniques

The design of the invitation has been achieved with minimal use of color: the outside is printed using three colors and the inside two.

USC Fisher Gallery cordially invites you to the opening reception and special programs for

Crossing Boundaries: Jamex and Einar de la Torre, Steven La Ponsie, and Ronald Gonzalez

November 18, 1999 – February 26, 2000

Opening Reception Tuesday, November 16, 1999
5 pm – 7 pm

RSVP requested (213) 740-4561.

Tuesdays at Fisher
A weekly program of dialogue, workshops, and performances, 12 noon to 1 pm.
For program information or to RSVP, please call (213) 740-5537.
Admission is free.

November 23
Dr. Max F. Schulz leads a Curator's Walkthrough of the exhibition.

November 30
Genevieve Barrios Southgate, Director of Children's Education at the Bowers Museum of Cultural Art, hosts a fun and informative talk on the history and tradition of Mexican dress.

December 7
Educator Martin Espino celebrates ancient Mexico with indigenous music featuring voice and Prehispanic instruments.

December 14
Children's Art Workshop. Artist Adam Hubbard leads this hands-on, just-for-kids sculpture workshop.

December 21
Holiday Open House. Enjoy refreshments and good cheer.

January 4
Family Fun Day: Storytellers dazzle and entertain your family with interactive tales during this event.

January 11
Meet the Artist: Featured artist Steven La Ponsie presents an in-depth discussion of his work.

January 18
Susanne Friend, Vice President of ConservArt Associates, Inc., shares the challenges and rewards of conserving a recent gift to USC Fisher Gallery: Maynard Dixon's "Jinks Room" murals.

January 25
Dr. Herbert Zipper Memorial Concert Series. Crossroads School Chamber Orchestra, conducted by James Forward, performs musical selections.

February 1
Adult Art Workshop, Part One. Artist Trevor Norris leads this hands-on clay sculpture workshop. No experience necessary. Workshop is limited to twelve participants, RSVP required.

February 8
Adult Art Workshop, Part Two. Put the finishing touches on your clay sculpture with a glaze.

February 15
Richard Meyer, Assistant Professor of Contemporary Art, University of Southern California, presents The Indelicate Line: A Critical Examination of **Crossing Boundaries.**

February 22
Mixed media artist Miquiztlicoatl conducts a gallery walkthrough exploring the cultural significance of iconography in selected works.

Wake Up Call!
Thursday, December 2, 1999, 6:30 pm.
The Gin D. Wong Conference Center (Harris Hall Room 101)

Featured artists Jamex and Einar de la Torre discuss the effect their Mexican/American cross-cultural experience has had on their art, the advantages of collaborating, and the shock of having their work destroyed by a religious zealot.

Moderated by Richard Meyer, Assistant Professor of Contemporary Art, University of Southern California.

Families at Fisher
Saturday, December 11, 1999, 12 noon

Bring the entire family for an afternoon of fun! Activities include sculpture-themed art workshops, live music, storytelling, facepainting, tours of the exhibition, and refreshments.

Designer
Christina Glahr

Art Director
Simon Schmidt

Illustrator
Christina Glahr

Photographer
Frank Voth

Design Company
Lorem Ipsum, Büro Für
Konzeption & Gestaltung

Country of Origin
Germany

Description of Artwork
Brochure to promote
surfing at Klitmoeller Beach
on the North Sea coast
of Denmark.

Page Dimensions
250 x 200 mm
$9^7/_8$ x $7^7/_8$ in

Format
Brochure

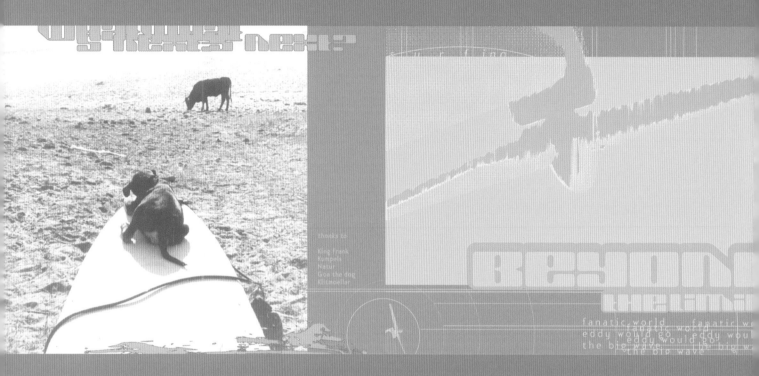

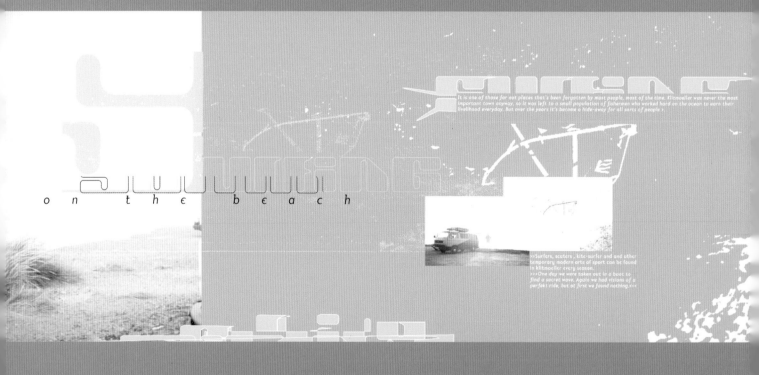

Klitmoeller Brochure

Although this evocative brochure, with its 'weathered' colors and rounded 'surfer' typography, alludes to the attractions of the beach in a rather abstract and oblique way, it is nonetheless quite clear. The text, which includes quotes from individual surfers and well-known pop songs, is sized and positioned to encourage closer scrutiny. Among the more obvious pictures, such as surfers on the water or a board strapped to the top of a van, there is an unexpected image with two animals (*opposite*, *top*) which immediately draws the viewer's attention.

The horizon is a key feature of this design. The photographic horizon is reinforced by a long line of text and the silhouette of a lone surfer looking out to sea, which align to create an alluring atmosphere.

relax
and enjoy

>>When the night has come, and the land is dark - when the moon is the only light we see, then I won't be afraid - oh I won't be afraid that the moon is the only light we will see.<< This could be the words of a surfer, sitting in front of his van, smelling the salt of the ocean, a fire burns out and he just relaxes. Waiting for the sun to go down...

...when suddenly he stands up, taking his wetsuit, braking the silence of the evening to go out. Nobody says a word, makes a guesture to stand up. It is the feeling that makes them all ready to get off to the sea. One after another catches his board and starts treading water

I stand up in the morning,
 at ot the sea and I smile.
 thing I miss, nothing I
 lously of, just living.

g I was looking
 d here.
 aradise.
 lace to live.

what we looked for is
search
for stuff

is what we found

I don't know how to explain, it's not comparabic with anything else in the world.If you don't know it, you won't miss it. But if you knew, you not exist without. It's the simplicity of total freedom.

Klitmoeller Brochure

Long Wharf Theatre

To represent eight different elements (plays, in this case) in one piece is always difficult. However, an interesting and pleasing unity has been achieved by the clever use of duotone images (*above*). A different typeface or type size has been adopted for each play and this device has been repeated on the back (*opposite*) to help segregate a mass of information: individual production notes, special ticket deals, an introduction by the Artistic Director, a seating plan, and booking form. The mix-and-match approach to the typography and the use of a limited color palette gives this side the attractive period feel of a page of old advertisements.

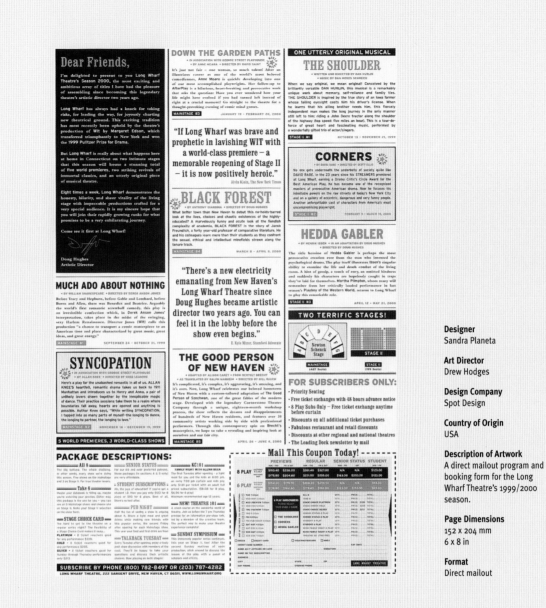

Designer
Sandra Planeta

Art Director
Drew Hodges

Design Company
Spot Design

Country of Origin
USA

Description of Artwork
A direct mailout program and booking form for the Long Wharf Theatre's 1999/2000 season.

Page Dimensions
152 x 204 mm
6 x 8 in

Format
Direct mailout

Designers
Yacht Associates and friends

Illustrator
Mark Thomson (departures spread)

Photographers
S. Edwards (cover), Red James (Japanese spread), Barnaby Wallace (departures spread)

Design Company
Yacht Associates

Country of Origin
UK

Description of Artwork
162-page book

Page Dimensions
245 x 303 mm
9⁷/₈ x 12 in

Format
Book

Blag—The Book

This high-end fashion and style book treats the reader to a collage of verbal explanations and imagery on a diverse selection of subjects. The bewildering range in the style of images, along with the title, provokes the reader to assess and reassess the intention and meaning of the book. Printed on matt paper, in contrast to the usual glossy magazine stock, the whole book can be seen to be questioning the fashion-magazine-as-artifact status quo.

TOKYO

Prague	OK662	Landed
Paris-CdG	AF822	Landed
Frankfurt	LH4014	Landed
Munich	LH4082	Landed
Istanbul	IL7031	Landed
Zurich	SR808	Landed
Geneva	SR838	Landed
Budapest	MA616	Landed
Vienna	OS469	Landed
Madrid	IB3172	Landed
Rome	AZ210	Landed
Milan	AZ246	Expected
Athens	OA265	Expected
Zurich	SR810	Landed
Lisbon	TP464	Expected
Warsaw	LO285	Expected

HEATHROW AIRPORT, LONDON is the world's busiest international airport with over 55 million passengers a year, taking 57 million pieces of luggage on over 420,000 flights a year

Open 24 hours, 365 days a year, over 85 aircraft land & take off per hour at peak times

Over 500 taxis are waiting at the airport at any one time

13 million vehicles a year enter the terminal and there are 15,800 parking spaces available

100 fire fighters are on 24 hour standby and can reach any part of the 3,000 acre airport in less than 2 minutes

Every day the public is served over 27,000 cups of tea & coffee, 7,000 pints of beer, and 7,000 sandwiches, making 1 tonne of litter daily

Passengers passing through Heathrow spend over £190 million a year on duty free, food, car hire & parking

Every hour, Heathrow sells over 350 bottles of whiskey, 50 bottles of champagne, 40 lipsticks, 170 bottles of perfume & 60 bottles of aftershave

Perfume sales from Heathrow alone amount to 10% of the entire British market, book sales account for 6% of the national market

Grass on the airport is kept constantly at 6 inches high to avoid birds settling - at this height the birds can not spot predators so do not feed

The Swatch Shop sells 76,000 watches a year from a space the size of an average sitting room

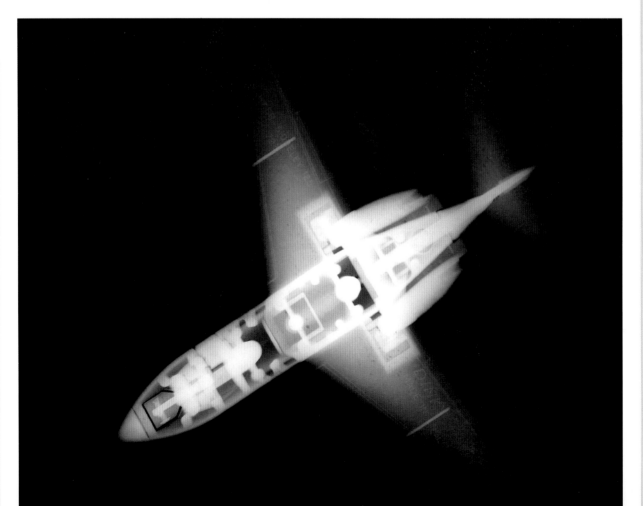

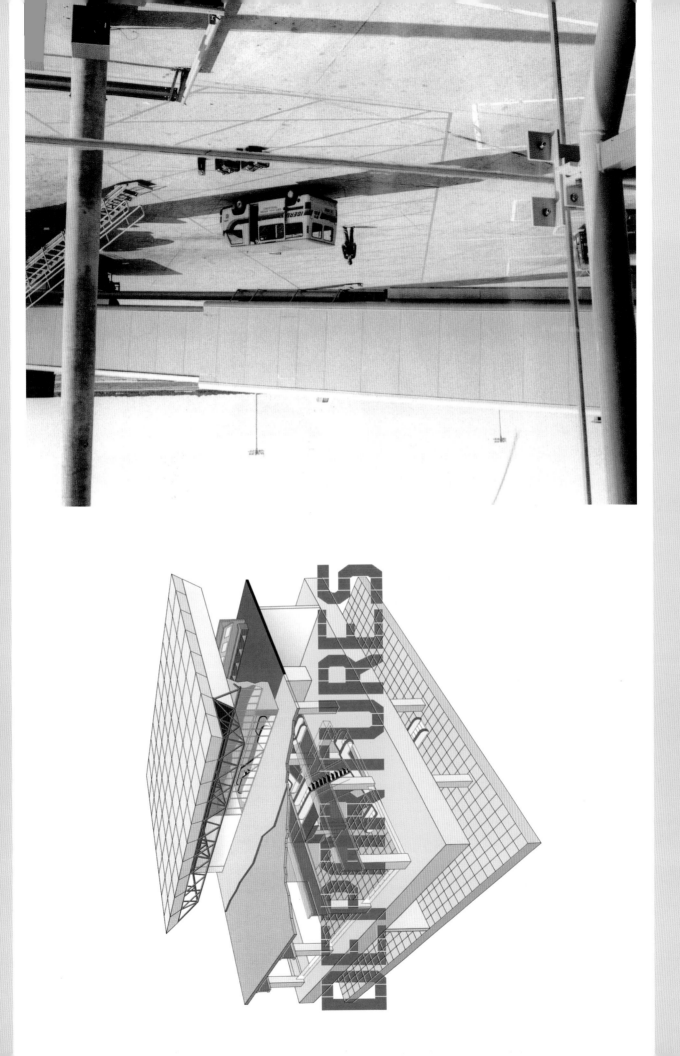

BAŞTAN AŞAĞI YEPYENİ NESNELER

Dünyanın ortasında bir Schuylkill'den çıkageldi
Küçük filolar, çağrılmış-arzulanmış, içlerinde taşıyarak

Dost gölgelerini, onun tanıdığı, herbiri getiriyordu
yaptığını, onun inandığı sudan ve arzudan,

Yerkürenin ortasında yaşayan, yarı insan
Ustalar, işlev neymiş bilmeyen, bilmek de istemeyen.

Bu adamcıklar zamanın pasıyla pas yeşili
Kanolarının küreklerini çeke çeke, binlerce binlerce.

Öyle biçimlerdeydiler ki, öyle derde deva biçimler,
Görünce bildi onların ince niyetini,

Anladı ki bu biçimler tam tamına biçimleriydi
Koskoca bir halkın, yaşlanmış düşüne düşüne...

Yatmış yıllanıyorlar belki de onların ataları
Tinicum'ın altında ya da küçük Cohansey'nin.

Wallace Stevens

Seçilmiş Şiirler. Faber & Faber: Londra, 1965.
(Çev. Fatih Özgüven - Nihal Koldaş)

25 Dünya, 1996-1997. Kağıt üzerine
suluboya. 17.8 x 12.4 cm. Milano,
Studio Guenzani'nin izniyle.
25 Worlds. 1996-1997. Watercolor
on paper. 17.8 x 12.4 cm.
Courtesy Studio Guenzani, Milan.

CANDICE BREITZ

Candice Breitz yalnızca bireyin ve kolektif kimliğin "saptanması" değişimin araştırma konusu değil, aynı zamanda dünyaya konuşmak için gösterdikleri ve güçlü olduğu bir bağlanğıcınız da ortaya koymak amacıyla yola çıkıyor. 1996 tarihli Double Durban'ı ele alalım. Burada, Breitz dikiz makinesi etkisi çok benzer bir Güney Afrika kamposundanın sınırı, ve karşımızdakimiz anlatımı gerçekleştirmesi yeni çıkılış...

Claire Callhoun

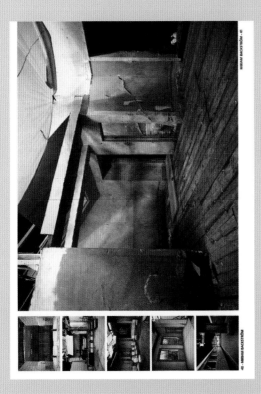

a design for the overture curtain of an unwritten opera

6th International Istanbul Biennial

When presenting the work of artists, the layout needs to serve the artworks without compromising the design itself. To anchor these layouts, the designers have used the consistent device of a 'running footer' at the base of each page which includes the folio number and the artist's name. The first page of each section has a small photograph of the artist, their year of birth, and address. Once established, such a layout allows framed images displayed as if in a gallery (*opposite page*) to sit comfortably alongside a more conceptual text-based work (*right*).

Designers
Gülizar Çepoğlu, Aysun Pelvan

Art Director
Gülizar Çepoğlu

Photographers
Various

Design Company
Gülizar Çepoğlu Graphic
Design Co.

Country of Origin
Turkey

Description of Artwork
276-page book for the 6th
International Istanbul Biennial
fine-art festival. The first of two
for each Biennial.

Page Dimensions
165 x 235 mm
6¹/₂ x 9¹/₄ in

Format
Book

Designers
Brad Bartlett, Danielle Foushee

Art Directors
Brad Bartlett, Danielle Foushee

Photographer
Brad Bartlett (cover)

Art College
Cranbrook Academy of Art

Country of Origin
USA

Description of Artwork
144-page book documenting
the work of 71 artists
graduating from the
Cranbrook Academy of Art.

Dimensions
241 x 165 mm
9'/₂ x 6'/₂ in

Format
Book

Cranbrook Graduate Book

The unsettling undercurrent generated by the ambiguously threatening image (*opposite, bottom*) contrasts with the clean typography of the word 'Cranbrook' to produce an arresting four-color cover. The inside spreads are economically monochrome yet nonetheless convey the individuality of each student's work.

Below and bottom: the freedom of composition in the first spread is a long way from the subtle formality of the squared-up images of flamingoes in the spread below it. This indicates that when a structure is needed it is there, and when it is less important it need not be imposed.

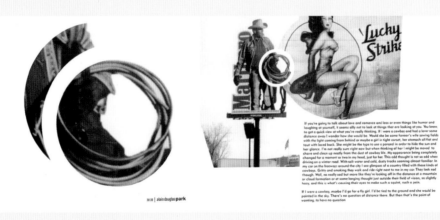

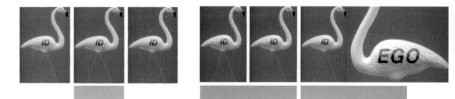

Designers
Dom Raban, Pat Walker

Illustrators
Dom Raban, Pat Walker,
Andrew Wilson

Photographer
Mark Harvey

Design Company
Eg.G

Country of Origin
UK

Description of Artwork
Promotional brochure for the
'Year of the Artist'—the UK's
largest ever nationwide arts
festival.

Page Dimensions
210 x 297 mm
8¼ x 11¾ in
Opening to a maximum
width of: 940 mm, 37 in

Format
Brochure

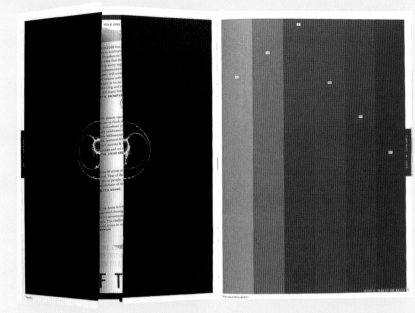

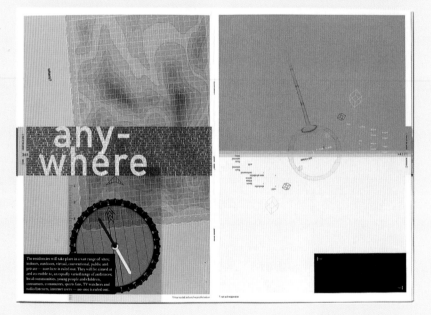

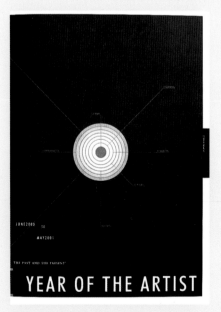

Year of the Artist

Based on the numerical sequence 1 (year), 4 (seasons), 12 (months), 52 (weeks), etc., this brochure is designed to promote the accessibility of contemporary art. Its visual appeal is enhanced by the use of vibrant colors indicating the different sections (*opposite, top right*) and the use of familiar imagery, such as the pull-out street scene. The accessible 'hands-on' nature of the project is shown by the inclusion of a do-it-yourself street cut-out kit (*bottom*).

Special Production Techniques

The use of fold-out pages has allowed the designers to create long landscape images which stretch the limitations of the brochure format and communicate the breadth of this arts festival.

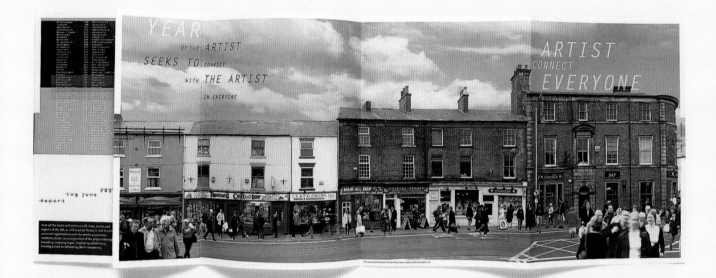

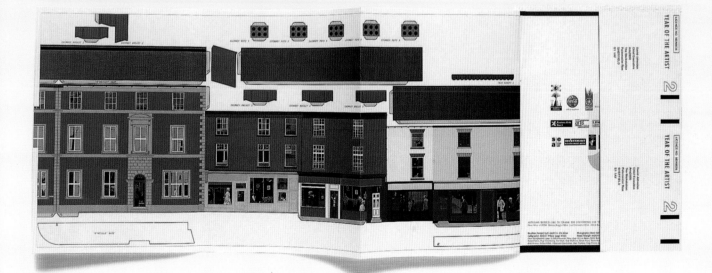

experiment

sweat

voice

craft

provoke

inspire

CCAC Scholarship Program

Help make it happen.

Designer
Bob Aufuldish

Art Director
Bob Aufuldish

Photographer
Douglas Sandberg

Hybrid Tool Designer
Karl Weiser

Design Company
Aufuldish & Warinner

Country of Origin
USA

Description of Artwork
A series of three postcards
sent to alumni of the California
College of Arts and Crafts
to solicit donations to a
scholarship fund.

Dimensions
152 x 229 mm
6 x 9 in

Format
Postcards

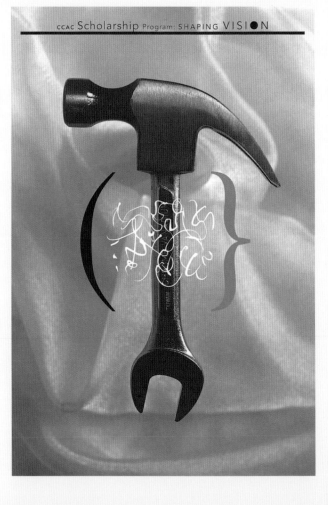

CCAC Scholarship Program: SHAPING VISION

CCAC Scholarship Program

Here, direct and apparently simple imagery is used to make the complex and intangible theme of scholarship immediately accessible. The clarity and unity of the images is enhanced through the use of only two colors—black and metallic silver—and the recurring textile backdrop. The photograph on each card is subtly suggestive of a different process associated with learning—original and unexpected ideas (*left*), individual expression (*center*), and the receiving and understanding of information (*right*). These are reinforced through the use of the abstract, white, central graphic which is itself encapsulated and 'processed' within a variety of parentheses.

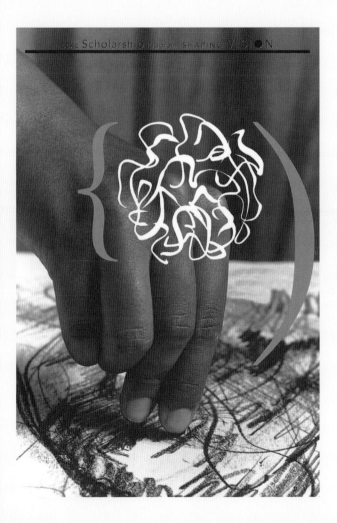

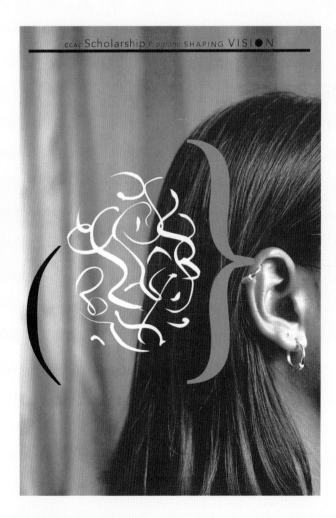

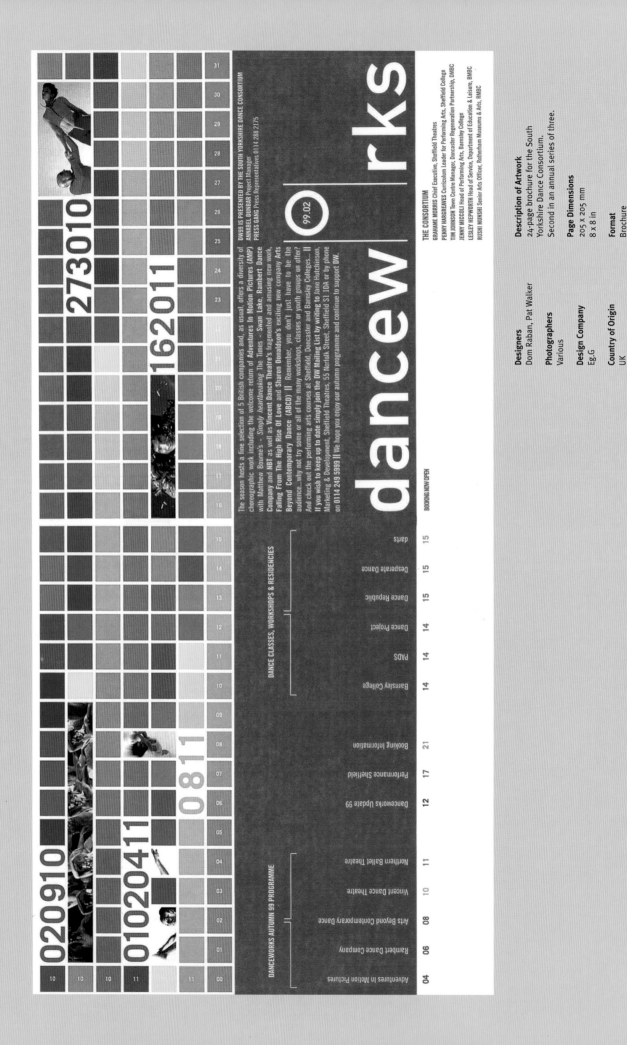

Designers
Dom Raban, Pat Walker

Photographers
Various

Design Company
Eg.G

Country of Origin
UK

Description of Artwork
24-page brochure for the South
Yorkshire Dance Consortium.
Second in an annual series of three.

Page Dimensions
205 x 205 mm
8 x 8 in

Format
Brochure

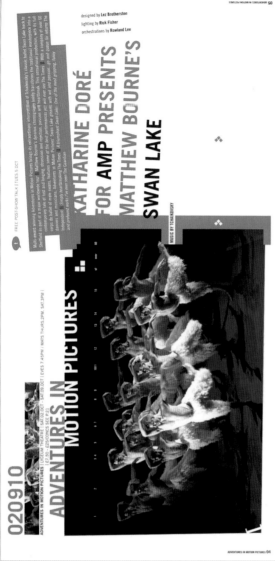

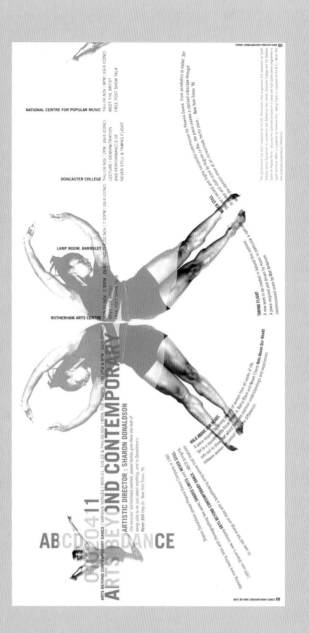

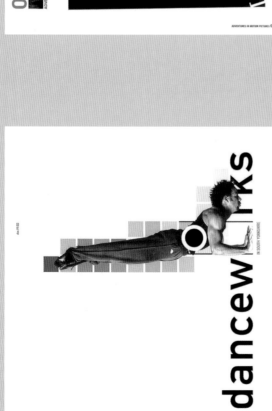

Danceworks

A powerful 'logo' (*above*), strong use of a colored grid (*above and opposite*), and consistent application of typeface and typesize have all been used to erect a framework within which the designers have then been able to play fast and loose with individual images. This approach allows a squared-up layout (*right, top*) to sit comfortably next to a free-flowing spread featuring cutouts (*right*), in which the typography reflects the motion in the leaping figure.

Special Production Techniques

The curved text (*right*) was produced with the use of two design programs: QuarkXPress and Illustrator.

Gillian Wearing, *2 into 1, 1997*

Rodney Graham, *Vexation Island, 1997*

Designer
Bob Aufuldish

Art Director
Bob Aufuldish

Photographer
Bob Aufuldish

Design Company
Aufuldish & Warinner

Country of Origin
USA

Description of Artwork
A fold-out announcement of the public program offered by the California College of Art and Crafts during the fall semester 1999.

Page Dimensions
152 x 229 mm
6 x 9 in

Format
Self-mailing announcement

Unless other-wise noted, all CCAC Institute programs—exhibitions, opening receptions, film screenings, and lectures are free and open to the public.
For more information, call 415.551.9210.

EXHIBITION: SAN FRANCISCO

SEARCHLIGHT: CONSCIOUSNESS AT THE MILLENNIUM
September 25–December 11, 1999
Logan Galleries and Carroll Weisel Hall
Montgomery Campus
1111 Eighth Street, San Francisco
Opening reception: Friday, September 24, 7–9 pm, featuring a special guest appearance by Deep Blue Jr.

This exhibition surveys thirty years of international contemporary art to reveal how consciousness has evolved as one of the most compelling artistic themes of our time. The exhibition includes over fifty works by more than thirty artists including Louise Bourgeois, Theresa Hak Kyung Cha, Stan Douglas, Douglas Gordon, Rodney Graham, Gary Hill, Robert Irwin, Iñigo Manglano-Oralle, Agnes Martin, Yoko Ono, Adrian Piper, Ad Reinhardt, Diana Thater, Bill Viola, Gillian Wearing, and La Monte Young and Marian Zazeela.

Logan Galleries
Hours: Monday, Wednesday, Thursday, Friday, and Saturday 11 am–5 pm Tuesday 11 am–9 pm; closed Sunday. Holiday closure: November 25–28

PUBLIC PROGRAMS: SAN FRANCISCO

SEARCHLIGHT: CONSCIOUSNESS AT THE MILLENNIUM PROGRAMS
Unless otherwise indicated, all *Searchlight* programs take place in Timken Lecture Hall on CCAC's Montgomery Campus in San Francisco. For more information, call the CCAC Institute at 415.551.9210.

SEARCHLIGHT LECTURE SERIES

Artist Talk: Jörg Herold
Tuesday, September 7, 7:30 pm
In this *Searchlight* pre-opening talk, German conceptual artist and filmmaker Jörg Herold will discuss his work, including the video installation *Körper im Körper, 1989*, featured in the *Searchlight* exhibition. The talk will be followed by a screening of some of the artist's early film works including *Sportfest 69, 1969–1988, Beiwerk, 1985*, and *Der Wurst-film, 1987*. Herold's work has been featured in documenta X (1997), the Venice Biennale (1990 and 1995), Prospect 93, and the Eighth Biennale of Sydney (1992). The *Searchlight* exhibition marks the first time his work has been shown in the United States.

Artist Talk: Stuart Sherman
Tuesday, September 21, 7:30 pm
Performer, video artist, and filmmaker Stuart Sherman will screen a selection of his works and discuss his unique approach to language, time, and mind. Sherman's films and videos

SEARCHLIGHT FILM SERIES
Seven evenings of experimental film explore the nature of conscious experience through the time-based medium of film. Presented by the San Francisco Cinematheque, this film series was organized by Steve Anker, Irina Leimbacher, and David Sherman.

Dawning of Awareness
Tuesday, October 5, 7:30 pm
These films trace a journey from the origins of consciousness through the development of language to the social order of adulthood. Films include *Epilogue, 1987*, by Matthias Müller, Super-8mm, color, sound, 16 minutes; *Scenes from Under Childhood: Section No. 3, 1970*, by Stan Brakhage, 16 mm, color, silent, 27.5 minutes; *Peggy and Fred in Hell: Prologue, 1985*, by Leslie Thornton, 16mm, b/w, sound, 21 minutes; *Zorns Lemma, 1970*, by Hollis Frampton, 16mm, color, sound, 60 minutes.

Flows of Perception
Tuesday, October 19, 7:30 pm
This program explores the phenomenology of the mind through the experiential and structural possibilities of cinema. Films include *1997B (Departure), 1997*, by Steve Polta, Super-8mm, color, sound, 7 minutes; *Opening the 19th Century: 1896, 1896/1991*, by Lumiere Brothers/Ken Jacobs, 16mm, b/w and color, sound, 9 minutes; *Short Film Series, 1975–1998*, by Guy Sherwin; 16mm, b/w, sound, 15 minutes; *Serene Velocity, 1970*, by Ernie Gehr, 16mm, color, 23 minutes; *Glass, 1998*, by Leighton Pierce, 16mm, color, sound, 7 minutes; *3.95 Untitled, 1995*, by Brian Frye, 16mm, b/w, silent, 3 minutes; *Don't Even Think, 1992*, by Scott Stark, Super-8mm, color, sound, 15 minutes; *S:TREAM:S:S:ECTION:S: ECTION:S:S:ECTIONED, 1968-71*, by Paul Sharits, 16mm, color, sound, 42 minutes.

In Search of Sense and Sequence
Tuesday, October 26, 7:30 pm
The creation/discovery/imposition of order and meaning is a ubiquitous urge of conscious life. The films in this program endeavor to make some "sense" of experience. Films include *Test, 1996*, by Kerry Laitala, 16mm, b/w, silent, 3 minutes; *An Algorithm, 1977*, by Bette Gordon, 16mm, color, sound, 10 minutes; *The Amateurist, 1998*, by Miranda July, video, color, sound, 17 minutes; *The Adventures of Blackie, 1998*, by Jeanne Finley and John Muse, video, color, sound, 9 minutes; *Poetic Justice, 1972*, by Hollis Frampton, 16mm, b/w, silent, 31.5 minutes; *Anatomy of Melancholy, 1999*, by Brian Frye, 16mm, b/w, sound, 12 minutes; *I'll Walk with God, 1994*, by Scott Stark, 16mm, color, sound, 8 minutes.

EXHIBITION: OAKLAND

INTERWEAVINGS
October 2–November 24, 1999
Oliver Art Center
5212 Broadway, Oakland
Opening reception: Friday, October 1, 6–8 pm
Organized by Yves Sabourin and Lawrence Rinder, *Interweavings* presents works made through collaborations among contemporary international artists and practitioners of the classic French crafts of lacemaking, tapestry, and embroidery. Among the featured artists are Ghada Amer, John Armleder, Marie-Ange Guilleriminot, Mona Hatoum, Fabrice Hybert, Annette Messager, and Jean-Michel Othoniel.

Oliver Art Center, Oakland campus
Hours: Monday, Tuesday, Thursday, Friday, and Saturday 11 am–5 pm Wednesday 11am–9 pm; closed Sunday. Holiday closure: November 25–28

PUBLIC PROGRAMS: OAKLAND

INTERWEAVINGS LECTURE SERIES
Unless otherwise indicated, all *Interweavings* programs take place in Nahl Hall on CCAC's Oakland campus. For more information, call the CCAC Institute at 415.551.9210.

Lecture: Yves Sabourin
Friday, October 1, 8 pm
Interweavings curator Yves Sabourin discusses

CCAC INSTITUTE PROGRAMS

CCAC Public Programs, Fall 1999

The striking juxtaposition of natural and urban images on the cover draws attention to the experimental and conceptual nature of many of the films and events offered in the program. The clear typography on the inside, with the second color printed beneath the black text, reflects the preoccupations of many of the talks which have to do with contextualism and the overlaying of meanings.

Special Production Techniques

Two-color printing (pale green and black) has been used to good effect to add a subtle depth to the duotone images on the front cover and for the overlaying of text on the inside.

Philippe Favier, *Les Milles et une Nuisent*, 1994–96

...struction] artist Martin Creed will make his first West Coast appearance, discussing his dryly humorous approach to conceptual art. Creed's work has been featured in the Eleventh Biennale of Sydney (1998) and in exhibitions at Cabinet Gallery, London; Gavin Brown's Enterprise, New York; and Art Metropole, Toronto. Creed also plays in the band Owada.

Ken Jacobs: From Muybridge to Brooklyn Bridge
Tuesday, October 12, 7:30 pm
Pacific Film Archive Theater
2575 Bancroft Way, Berkeley (New Location!)
The Pacific Film Archive presents filmmaker Ken Jacobs in one of his legendary live Nervous System Performances. "Jacobs not only operates his analytic projectors, he also hooks into our most primal processes of perception. Our basic ability to perceive figure and ground, movement out of stillness, to synthesize space and time are played with, as though we were hot-wired to the screen," says Tom Gunning in *Films that Tell Time: The Paradoxes of the Cinema of Ken Jacobs*.
General Admission $6

Symposium: The Art of Consciousness
Saturday, October 30, 1–9 pm
Advance reservations are strongly recommended; call 415.551.9202.
This special program includes a series of interdisciplinary presentations exploring the manifold ways in which art contributes to the understanding of consciousness. Speakers are George Lakoff, professor of cognitive science and linguistics, UC Berkeley; Alva Noë, assistant professor of philosophy, UC Santa Cruz; Pauline Oliveros, experimental musician; Vilayanur Ramachandran, director of the Brain and Perception Laboratory, UC San Diego; Eleanor Rosch, professor of cognitive psychology, UC Berkeley; Lawrence Rinder, *Searchlight* curator; Robert Thurman, professor of Indo-Tibetan Buddhist studies, Columbia University; and Bill Viola, artist.

Artist Talk: Gary Hill
Tuesday, November 30, 7:30 pm
Gary Hill will discuss his early video work *Why Do Things Get in a Muddle? (Come on Petunia)*, 1984, in which two texts, *Alice in Wonderland* and a "metalogue" from Gregory Bateson's *Steps Toward an Ecology of Mind*, are woven together in a mind-bending performance. A recent winner of the prestigious MacArthur Fellowship, Gary Hill is one of America's most highly regarded video artists.

Artist Talk: Stan Douglas
Tuesday, December 7, 7:30 pm
Stan Douglas's film installations lend a compelling twist to conventional narrative and documentary forms. In this rare Bay Area appearance, Douglas will discuss how his works have investigated aspects of consciousness. His work has been shown at the Dia Center for the Arts, New York; The Renaissance Society at the University of Chicago; the Institute of Contemporary Art, London; and the Art Gallery of Ontario, Toronto.

struction *of a Face, Red Cross Worker, Paris*, 1918, director unknown, 16mm, b/w, silent, 4 minutes; *Magenta*, 1997, by Luis Recoder, 16mm, color, sound, 9.5 minutes; *Sirius Remembered*, 1959, by Stan Brakhage, 16mm, color, silent, 12 minutes; *The Five Bad Elements*, 1997, by Mark LaPore, 16mm, b/w, sound, 33 minutes; *Parallel Space: Inter-View*, 1992, by Peter Tscherkassky, 16mm, b/w, sound, 18 minutes; *Mother*, 1988-98, by Luther Price, Super-8mm, color, sound, 25 minutes; *Time Being*, 1991, by Gunvor Nelson, 16mm, b/w, silent, 8 minutes.

Contested Personas
Tuesday, November 9, 7:30 pm
This program examines several sites of struggle and affirmation in the power plays inherent in the socio-historical awareness of self and others. Films include *Smoke*, 1995-96, by Pelle Lowe, Super-8mm, color, sound, 24 minutes; *Mute*, 1991, by Greta Snider, 16mm, color, sound, 14 minutes; *Chronicles of a Lying Spirit (by Kelly Gabron)*, 1992, by Cauleen Smith, 16mm, color, sound, 5.5 minutes; *Perfect Film*, 1986, by Ken Jacobs, b/w, sound, 23 minutes; *Les maîtres fous*, 1955, by Jean Rouch, 16mm, color, sound, 36 minutes; *Epileptic Seizure Comparison*, 1976, by Paul Sharits, 16mm, color, sound, 30 minutes.

Conscious Spaces
Tuesday, November 23, 7:30 pm
These films explore space and architecture through their existence in time. Films include *Wavelength*, 1966-67, by Michael Snow, 16mm, color, sound, 45 minutes; *Paris and Athens*, 1994, by Lynn Kirby, video, color, sound, 14 minutes; *News from Home*, 1976, by Chantal Akerman, 16mm, color, sound, 90 minutes.

Sleep-Over
Friday, December 3, through Saturday, December 4, 12 am–6 am Oliver Art Center, Oakland
Bring your sleeping bag and mat to an overnight screening of Andy Warhol's *Sleep*, which embodies the paradoxes of film and consciousness first-hanc as the audience drifts in and out of consciousness. Doughnuts served at 6 am. *Sleep*, 1963, by Andy Warhol, 16mm, b/w, silent, 321 minutes.

Support for *Searchlight: Consciousness at the Millennium* has been provided by the National Endowment for the Arts; Judith and William Timken; Rena Bransten; Gloria Brown Brobeck; Alfred and Eunice Childs; Carla Emil and Richard Silverstein; Anthony and Celeste Meier; Nancy and Steven H. Oliver; Susan and Richard Watkins; The Good Guys!; Norma Schlesinger; Byron Meyer; and Paul and Elizabeth Wilson.

The CCAC Institute programs are made possible through the generous support of Mrs. Paul L. Wattis; The James Irvine Foundation; Ann Hatch/California Tamarack Foundation; The National Endowment for the Arts; Grants for the Arts/San Francisco Hotel Tax Fund; Lannan Foundation; California Arts Council, a State Agency; LEF Foundation; Clinton Walker Foundation; Gyöngy Laky; Pro Helvetica, Arts Council of Switzerland; Tecoah and Thomas Bruce; and members of the CCAC Institute Council.

Wednesday, October 13, 7:30 pm
Artist Sylvie Skinazi and lacemaker Brigitte Lefebvre discuss their collaboration.
Demonstration: Sylvie Deschamps
Wednesday, October 20, 7:30 pm
CCAC Textile Department, 5275 Broadway, Oakland
Sylvie Deschamps presents an embroidery demonstration and workshop. For more information, call the Textile Department at 510.597.3703.
Artist Talk: Jean-Michel Othoniel and Sylvie Lezziero
Wednesday, October 27, 7:30 pm
Artist Jean-Michel Othoniel and embroiderer Sylvie Lezziero discuss their collaboration.
Artist Talk: Johan Creten and Mylène Salvador
Wednesday, November 3, 7:30 pm
Artist Johan Creten and lacemaker Mylène Salvador discuss their collaboration.

Interweavings is part of Côte Ouest: A Season of French Contemporary Art. It is made possible by the support of the French Ministry of Foreign Affairs through AFFA and French Cultural Services; Étant donnés; The French American Endowment for Contemporary Art; and Tom and Jan Boyce.

Events are subject to change. Please call phone numbers listed with each event to confirm dates, times, and locations.

CCAC's Oakland Campus
5212 Broadway (off Clifton)
Oakland 94618
(510) 594-3600

CCAC's San Francisco Campus
1111 Eighth Street (near Wisconsin and 16th streets)
San Francisco, CA 94107
(415) 703-9500

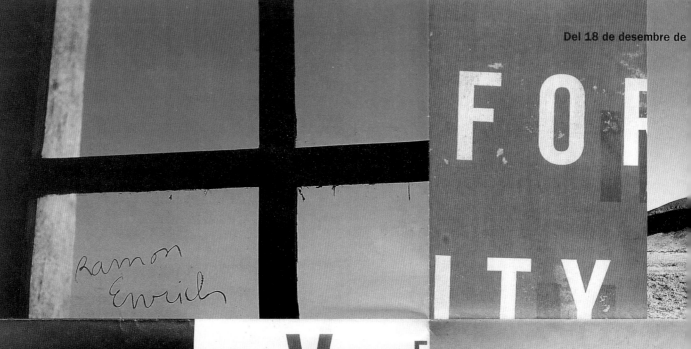

FOR
ITY

Galeria 22, Sant Josep, 22, 08700 Igualada, B

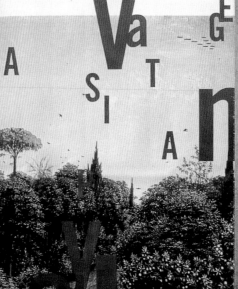

Ramon Enrich

Galeria 22 i Ramon Enrich tenen el plaer de convidar-vos
a la inauguració de l'exposició, que tindrà lloc el proper
divendres dia 18 de desembre de 1998 a les 20 h.

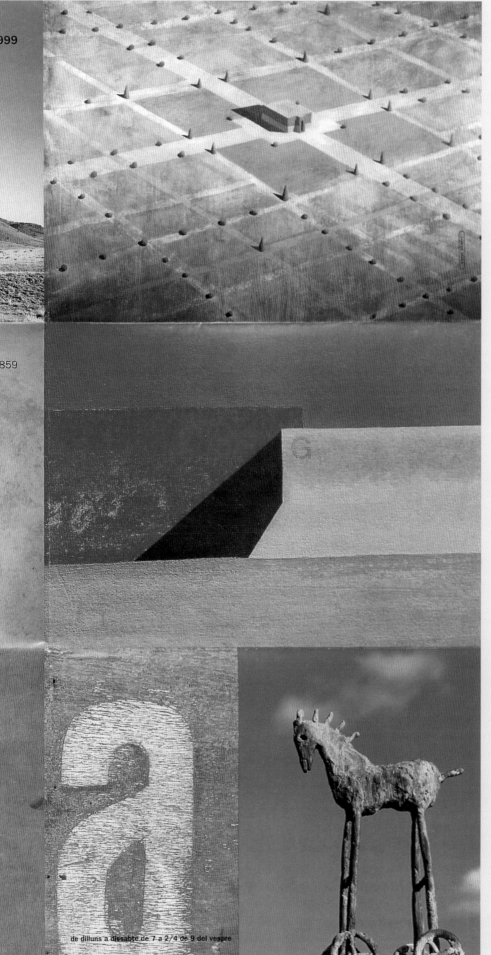

3 de gener de 1999

ain. Tel. 938 050 859

de dilluns a dissabte de 7 a 2/4 de 9 del vespre

Galeria 22

Whether spread out as a poster (*left*), or folded to one ninth of its size to make an invitation, this eye-catching design gives a strong sense of the artist's preoccupations. The juxtaposition of rich imagery—photograph next to painting and close-up next to long-shot—reveals a concern with the geometric structure of images. This is something seen in the paintings themselves which, grouped together in this way, also show the extent to which the colors of landscape and sky have influenced the artist's color palette.

Designer
Lluis Jubert

Art Director
Ramon Enrich

Illustrator
Ramon Enrich

Photographer
Ramon Enrich

Design Company
Espai Grafic

Country of Origin
Spain

Description of Artwork
An invitation to an exhibition at a Barcelona art gallery, which can be unfolded to make a poster.

Dimensions
210 x 150 mm
8¹/₄ x 5⁷/₈ in (folded)
630 x 450 mm
24³/₄ x 17³/₄ in (unfolded)

Format
Invitation/Poster

This project has indeed married the convenience of global communications with happy snapping.

Diese Projekt verbindet gekonnt die Einfachheit der globalen Kommunikation mit fotografischen Schnappschüssen.

These images are the result of recording the day, by shooting thirty-six shots, one every 20 minutes between 8am and 8pm, then rewinding the film and mailing it to a distant friend who is asked to repeat the process. All in all one hundred individuals exposed around 1800 frames.

Die vorliegenden Bilder sind das Ergebnis fotografischer Tagesdokumentationen. Die belichteten Filme wurden jeweils an eine zweite Person geschickt, die den Vorgang wiederholte. So sind unter der Teilnahme von rund 100 Menschen weltweit über 1800 Doppelbelichtungen entstanden.

ISBN 3-00-004741-7

Double take

Introduction by Liz Farrelly

Mit Texten von Judith Hermann und Gregor Sander

Shift!

What you see here is an exercise in techno-gap-plugging.

Liz Farrelly, Introduction Doubletake

Shift! Doubletake

The originality of the initial idea (see jacket text, *above left*) and the intriguing nature of this international photographic project have been borne out by the resulting imagery. The layout of the spreads reflects the atmosphere of the double-exposed pictures and, critically, does not intrude upon them. This work stands for itself.

Dresden

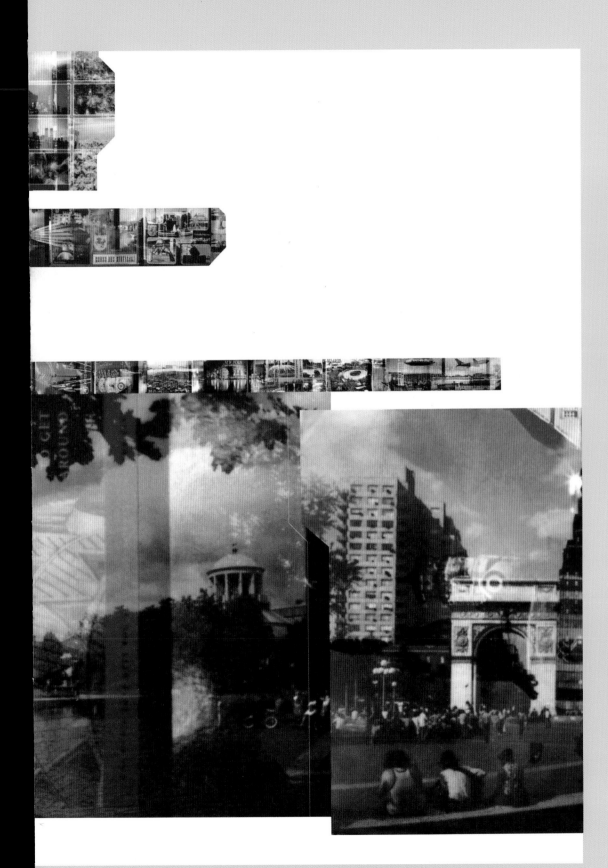

Concept
Anja Lutz, Christian Küsters

Designers
Anja Lutz, Christian Küsters,
Julia Guther

Art Director
Anja Lutz

Photographers
Previous spread, right-hand
page: Amy Auerbach and
Tobias Melzer (*top, center*),
Sergi and Lydia Carzola (*center
and top, right*), Corinna Gab
and Rudi Feuser (*bottom*). This
spread: Anja Osterwauder and
Oliver Krimmel.

Design Company
Shift!

Country of Origin
Germany

Description of Artwork
160-page book documenting a
photography project involving
double-exposed images from
around the world. Introduction
by Liz Farrelly and short stories
by Judith Hermann and Gregor
Sander.

Page Dimensions
225 x 168 mm
8⁷/₈ x 6⁵/₈ in

Format
Book

GLOSSARY OF USEFUL TERMS

ADOBE ILLUSTRATOR
A popular graphic/illustration manipulation program used by many designers for both printed and electronic publication.

ADOBE PHOTOSHOP
The industry-standard image manipulation program used to prepare images for publication.

CMYK (COLOR PRINTING)
The printing of pages in full color through the application of four separate colors in succession: Cyan (blue), Magenta (pink), Yellow, and K (black). K is used for black, because using B could cause confusion between blue and black. It is possible to combine different types of color printing on the same sheet of paper by, for example, using four colors on one side and a single color on the reverse. This is referred to as 'four-back-one' printing. If this technique is used to produce a book then when the printed sheet, or signature, is folded the four- and one-color pages appear alternately throughout the publication.

CAP HEIGHT
The measuremant from the baseline to the top of a capital letter.

DUOTONE
The process by which the complete range of tones, from light to dark, is represented using two colors. Often, one of these two colors is black, but any two printer's inks can be used.

FOLIO
The page number in a book.

GUTTER
The line running along the center of a book where the pages are bound together. Gutter can also be used to refer to the space between two columns of type.

LEADING
The amount of space, measured from baseline to baseline, between two or more lines of type.

LITHOGRAPHIC PRINTING
The most common form of commercial printing process in which the text/image is first etched onto a metal plate. This plate is often curved and fits onto a fast-rotating drum. Ink is applied to the plate which is then pressed against a second rotating drum, usually covered in a rubber blanket, onto which the inked image is transferred. This second drum is then rolled over a sheet of paper printing the image onto the paper. This process is technically called Offset Lithographic Printing because the text/image is not printed directly but first 'offset' onto an intermediate surface before finally being printed onto the paper.

OVERPRINTING
The printing of one color on top of another.

PIXEL
The basic unit that makes up an image viewed on a TV or computer monitor. The ultimate size of an electronic image when viewed on a screen depends on its dimensions in pixels and the resolution of the screen. The higher the resolution of the screen, the smaller—and the more clearly defined—the image will appear.

POINT SIZE
In typography, still the most common unit of measurement used to denote the size of a typeface. There are approximately 72 points to the inch.

QUARK XPRESS
A page-layout computer program used in the production of all types of design.

REVERSE OUT/KNOCK OUT
In printing, the technique of creating text/ outline/image by taking away the color from a particular area to allow the paper beneath, or another ink/inks, to show through without overprinting.

SERIF
In typography, a serif typeface is characterized by additional strokes at the extremities of each character. A typeface that lacks this is referred to as sans serif. Baskerville is an example of a serif face; Univers is a sans-serif face.

SIGNATURE
Books are often produced by printing a number of pages (usually 4, 8, 16, or 32) onto a single sheet of paper. Each of these sheets is then folded to form a section of the book. These sections are known as signatures.

SILK-SCREEN PRINTING
A method of printing in which the ink is forced through a mesh made from fine material (originally silk) onto the surface to be printed. It is often used in poster printing.

TYPEFACE
The style or design of the type.

X-HEIGHT
The measurement from the baseline to the top of a lower-case letter.

INDEX OF DESIGNERS, DESIGN COMPANIES, AND ART COLLEGES

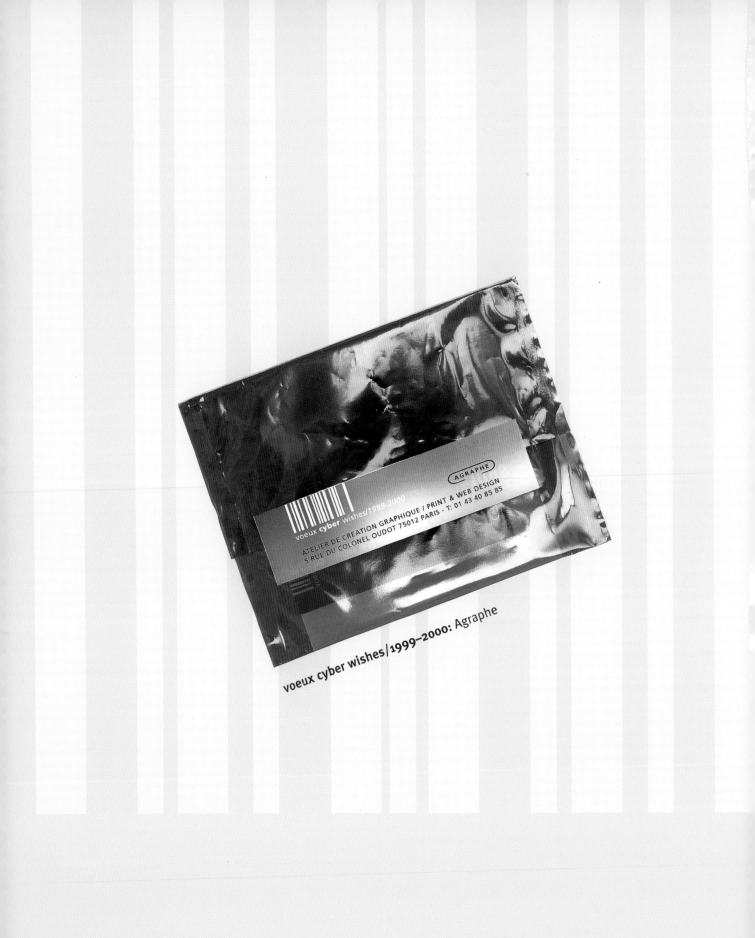

voeux cyber wishes/1999–2000: Agraphe